MW00475766

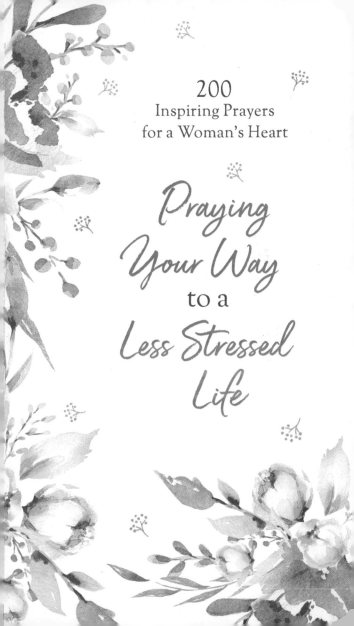

200
Inspiring Prayers
for a Woman's Heart

Praying
Your Way
to a
Less Stressed
Life

200
Inspiring Prayers
for a Woman's Heart

Praying Your Way to a Less Stressed Life

JESSIE FIORITTO

BARBOUR
PUBLISHING

Published by Barbour Publishing, Inc., 1810 Barbour Drive, Uhrichsville,
Ohio 44683, www.barbourbooks.com

Our mission is to inspire the world with the life-changing message of the Bible.

Member of the
Evangelical Christian
Publishers Association

Printed in China.

Pray Your Worries Away

Lord, I'm wringing my hands again. But I know where to turn with my worries—to Your Word. I've come seeking answers, a divine easing to my mercurial stress levels that spike the moment my feet dangle over the heat of another tough day, a bad decision, strained finances, illness, or a wayward child. And in this verse I find hope: pray about everything. *Every little thing.*

If I believe You are the Big Deal, the Creator of this glorious universe—the Creator of *me*—then I must believe You've got this. How very arrogant of me to think that my problems could ever be Your final straw. God, I commit to asking what *You* think about everything happening in my life. Every. Little. Thing. Because You've got this. Amen.

Don't worry about anything, but in everything,
through prayer and petition with thanksgiving,
present your requests to God. And the peace of God,
which surpasses all understanding, will guard
your hearts and minds in Christ Jesus.
PHILIPPIANS 4:6–7 CSB

Unburdened

Jesus, You're right here beside me—feeling every thrumming nerve ending in my body, the angst in my mind, and the weight of burden pressing on my shoulders. But, Jesus, You promised Your burden was light. So I know this load of stress must not be from You.

The world around me offers nothing but the weight of expectations—expectations I'm woefully unable to consistently meet. The only thing I seem consistent in right now is the failure to live up to a Facebook-perfect life. But then I remember that when I came to You, Jesus, I exchanged all those heavy expectations for free grace. And suddenly, all my failures no longer carry the weight of the world because You are pleased with me. Thank You, Jesus. Amen.

For it is by grace you have been saved, through faith—
and this is not from yourselves, it is the gift of God—
not by works, so that no one can boast.
EPHESIANS 2:8–9 NIV

An Uplifting Word

Jesus, sometimes negative voices overtake my thoughts. They rail at me in harsh judgment every time I stumble. I hear selfishness, pride, and guilt putting me down, hissing that I am all alone. These murmurs of condemnation *do* feel like a dark cloud hovering over my life. But I know where these voices come from—and it isn't You, Jesus. Because You love me, and Your voice is never harsh, condemning, or demeaning. You are here for me, *always*.

Speak to me, Jesus. Calm my fears. Your grace abounds and stirs the air like a fresh gale. I praise You, Jesus, for saving me. In the absence of condemnation, I can bask in the warm sunshine of Your smile. And I know that You will never leave me. Amen.

With the arrival of Jesus, the Messiah, that fateful dilemma is resolved. Those who enter into Christ's being-here-for-us no longer have to live under a continuous, low-lying black cloud. A new power is in operation. The Spirit of life in Christ, like a strong wind, has magnificently cleared the air, freeing you from a fated lifetime of brutal tyranny at the hands of sin and death.
ROMANS 8:1–2 MSG

Singing over Me

God, over and over Your Word assures me of Your unending love. But my life is full of struggles. And I struggle to believe sometimes that You could possibly be happy with my fumbled attempts at obedience, my constant failures. My heart cries, "Don't look, Jesus, I messed up again!"

Jesus.

Oh, yes, Jesus! The tension inside me eases at Your name; my spirit releases a pent-up breath. Jesus, You did it for me. . .because I couldn't. You lived my righteousness for me, died my death to absorb God's wrath over sin. I am now righteous and blameless! I have been so stressed and worried about never stepping out of line, but You are delighted with me! I'm going to tarry with this truth for a moment: *You. Love. Me.* Father, I see Your smile. Amen.

"The LORD your God is with you, the Mighty Warrior who saves. He will take great delight in you; in his love he will no longer rebuke you, but will rejoice over you with singing."
ZEPHANIAH 3:17 NIV

Way Maker

God, my stress spikes because I just don't know what to do. Where to turn for help. Which decision is the *right* one. I seek out friends and scavenge between the covers of yet another self-help book—looking for answers, understanding, and wisdom. And then I hear Your voice: *"Ask Me."*

I've wasted so much anxiety on seeking answers everywhere except the Alpha and Omega, the source of all wisdom. God, what should I do? Please give me wisdom. I will wait patiently for Your answers, because I know You have perfect, unexpected solutions. I doubt the Israelites expected You to make a way through the Red Sea, and yet You did. And You will show me the way through my problems too. Amen.

*If any of you lacks wisdom, you should
ask God, who gives generously to all without
finding fault, and it will be given to you.*
JAMES 1:5 NIV

King of My Heart

God, what things have I placed before You in my heart? I know I have given Your throne away at times. I have told you that *tomorrow* I will read my Bible; *tomorrow* I will pray about the decisions and circumstances that are troubling my sleep; *tomorrow* I will commit to that Bible study or prayer group or even just to reaching out to my neighbor. *Tomorrow.* Because today I have to get things done.

How wrong I have been. You are in all things, and all things are held together by You. And yet, I somehow believe that I can pull together the unraveling threads of my life all by myself. What unmitigated pride I've indulged. God, please forgive me. Help me to crown You King of my heart. Amen.

Dear children, keep away from anything
that might take God's place in your hearts.
1 JOHN 5:21 NLT

Talk to Him Always

Lord, You have called me friend, and more. . . beloved daughter. You have established our relationship through Jesus, who made it possible for me—with my dirt encrusted and ragged edges—to cozy right up to Your throne and say, "Hey, Dad, what do You think about this job opportunity or the problems I'm having with my son? I could use Your advice." After all, what is friendship if not a long conversation between two people—the kind that takes an entire lifetime to close.

And yet, too often in my frazzled life, I drop my end of the dialogue. You want to ease my fears and relieve my burdens. . .I just forget to talk to You about them. Help me to constantly pray. Amen.

Pray constantly, give thanks in everything;
for this is God's will for you in Christ Jesus.
1 THESSALONIANS 5:17–18 CSB

Every Moment

God, I don't even think about starting my day without a steaming jolt of caffeine. It's automatic. I wake up. I pour coffee. I drink coffee. But have I made You as integral in my day? Do I *need* You like I need caffeine and chocolate? Or have I been doing this life thing on my own, forgetting to acknowledge that I need You every minute of every single day for the rest of my life?

There's no substitute for You. I give You my worries, my stresses, my fears, my insecurities, my spectacular failures, the entire glorious mess—it's Yours. I just need You to sustain me. I trust Your great love for me and Your unmatched power. You will take care of me. Amen.

Cast your cares on the LORD and he will sustain you;
he will never let the righteous be shaken. . . .
But as for me, I trust in you.
PSALM 55:22–23 NIV

Above All Else

God, why do I allow worry to choke out my peace and joy—my sense of security? I'm striving after things that You've told me I don't need to worry over. Help me to seek You *first*—and seek You *always*. You are intimately acquainted with all my needs. You understand my fears and know my desires.

Lord, my stress stems from not seeking Your kingdom above all else. Show me the things that I have been running after, Father, that are not of Your kingdom. I want to walk away from sin, not because I think I can earn Your love, but because You already love me. And I love You. Teach me to rest as serenely in Your care as the luxuriously gowned wildflowers. Amen.

"If God cares so wonderfully for wildflowers that are here today and thrown into the fire tomorrow, he will certainly care for you. Why do you have so little faith? So don't worry about these things, saying, 'What will we eat? What will we drink? What will we wear?' These things dominate the thoughts of unbelievers, but your heavenly Father already knows all your needs. Seek the Kingdom of God above all else, and live righteously, and he will give you everything you need."
MATTHEW 6:30–33 NLT

Greener Pastures

Jesus, my strong, sure Shepherd, You have made things so good for me! But this world and our enemy are so accomplished at making sin look delectable. I might even convince myself that it's better than what You've given me. . .but then I remember that the wages of sin is death. And You've given me wonderful life!

Here in Your soft green grass I rest from my stress. I put my hope and trust in Your capable hands. When I take in the place You've led me to—undeserved grace, love that You will never take back, and righteousness as if I'd never been stained by sin—how could I ever wish to walk out of this meadow? Father, may I never again think the grass is greener outside Your pastures. Amen.

God, my shepherd! I don't need a thing. You have
bedded me down in lush meadows, you find me quiet
pools to drink from. True to your word, you let me
catch my breath and send me in the right direction.
Even when the way goes through Death Valley,
I'm not afraid when you walk at my side. Your
trusty shepherd's crook makes me feel secure.
Psalm 23:1–4 msg

All Powerful

Lord, I'm afraid to let go and give You control. But this mindset leaves me with nothing but anxiety. I feel small and fearful when I admit I can't control much of anything. But You, Lord, are the master of all. You have all the power. A mere word from You snapped a universe into existence and breathed life into dead matter.

Father, bolster my trust in You—in Your power over this world; in Your great, unmatched love for me; in Your wisdom to work all things out for good for those who love You and are called according to Your purpose. In relinquishing control to You, I find rest from my constant striving because I believe—I *know*—that You can handle the circumstances causing my stress. Amen.

"He spreads out the northern skies over empty
space; he suspends the earth over nothing. . . .
The pillars of the heavens quake, aghast at his rebuke.
By his power he churned up the sea. . . . And these
are but the outer fringe of his works; how faint
the whisper we hear of him! Who then can
understand the thunder of his power?"
JOB 26:7, 11–12, 14 NIV

A New Game Plan

God, I trust You. I know that You are able and that You love me. But I harbor fears that lead to stress. Fears about my finances, my children's future, my health. At times this world can feel like such an uncertain and dangerous place. And evil things do happen. . . so I need to put in play a game plan to win victory over my stress.

Father, I will meditate on Your Word so that Your truth and promises overtake my thoughts and crowd out the enemy's lies. Lord, help me see the unhealthy ways that I try to handle my stress, like binge eating or snapping at my family, so I can turn toward You as my ultimate stress reliever. In Jesus' name, amen.

Don't be gullible in regard to smooth-talking evil.
Stay alert like this, and before you know it the God
of peace will come down on Satan with both feet,
stomping him into the dirt. Enjoy the best of Jesus!
ROMANS 16:20 MSG

Experience His Peace

Lord, I need Your peace to descend upon the troubled waters of my mind. When the winds kick up and the waters become choppy, my stress rises. When my heart is troubled, I need Your peace to cocoon my troubled mind in peace—the peace that passes all understanding. Because You, Jesus, can stand in the midst of my storm and say, "Be still!"

Lord, even if the storm is still raging around me, my soul is at peace. Send Your peace to guard my heart and mind today against the fears that assault me. Jesus, when I put my trust in Your power over the storms, my fears shrink and I am no longer afraid. Help me to remember that Your peace is already mine. Amen.

Peace I leave with you; my peace I give you.
I do not give to you as the world gives. Do not
let your hearts be troubled and do not be afraid.
JOHN 14:27 NIV

A New Way of Thinking

Lord, I don't want to be stuck in my old pattern of thinking, doing things the same worn-out way and getting the same tired, disappointing results. Change my way of thinking and bring it into the light of Your good and holy ways.

The world says I should fear for my future and stress about things that are beyond my control, but You say that I can pray. That You will hear my prayer and answer me. And that You will never leave me or forsake me. I'm suddenly seeing my stress-inducing fears in a whole new way. I know that *nothing* is beyond Your control. And I *fully* trust You, because You love me and have good plans for my future. Amen.

Do not conform to the pattern of this world,
but be transformed by the renewing of your mind.
Then you will be able to test and approve what
God's will is—his good, pleasing and perfect will.
ROMANS 12:2 NIV

Faith under Pressure

Father, usually when I find myself in the midst of difficult situations my prayer is "Get me out of here!" I ask You to take away the hard times because I want relief from the stress and pressure. But You've shown me a different perspective on these hard times. They're a gift—a gift that is working to transform me into a person who is more like You, Jesus. And Your life is the ultimate model.

These stress-inducing times are refining my faith, contouring me into someone who is more loving, more compassionate, more patient, more kind—more like You, Jesus. Now instead of running from the hard stuff, I thank You for the work it's doing to change and strengthen me. Amen.

Consider it a sheer gift, friends, when tests and challenges come at you from all sides. You know that under pressure, your faith-life is forced into the open and shows its true colors. So don't try to get out of anything prematurely. Let it do its work so you become mature and well-developed, not deficient in any way.
JAMES 1:2–4 MSG

Hard-Pressed Prayers

Lord, I'm feeling the crushing force of hard places. I'm anxious and afraid. I look all around for a way out, for answers. . .but I don't cry out to You. I forget to pray about my problems.

Lord, the Psalms say that when I feel hard pressed, when it seems like circumstances box me in and fear scratches at me, I can cry out to You—and You will bring me into an open place. You will give me breathing space. You promise that You are with me and will never leave me. I release my fears to You, the Way Maker. When I'm ready to give up, You show up with solutions I never could have imagined—I only have to ask. Thank You, Jesus. Amen.

When hard pressed, I cried to the LORD; he brought
me into a spacious place. The LORD is with me;
I will not be afraid. What can mere mortals do to me?
PSALM 118:5–6 NIV

Whom Shall I Fear?

Lord, You are the God of the universe. It's easy to skip right on by the magnitude of that fact. So I want to sit with this knowledge for a moment and meditate on just who You are.

Astrophysicists say that the universe contains more than 100 billion galaxies. 100 *billion*—with a B. And probably more. One hundred billion galaxies and counting. . . That's unfathomable. The depths of Your knowledge and power are every bit as unfathomable, God. And yet I stress over the economy or my kids' attitudes.

The God of 100 billion galaxies knows my name, cares about my problems, and promises never to leave me or forsake me. Now *that's* unfathomable! Father, forgive me for losing sight of just who is fighting for me. Amen.

In my distress I prayed to the LORD, and the LORD
answered me and set me free. The LORD is for me,
so I will have no fear. What can mere people do to me?
PSALM 118:5–6 NLT

Guard Your Mind

God, I realize that this life is an epic battle between good and evil, the battle for my mind. My enemy knows that if he can gain control of my mind, then he has won; because when my sinful nature controls my mind, it leads only to death. But when my thoughts are under the guidance of Your Spirit, I have peace and life.

Lord, help me to heed the Spirit's whispers and reject my own self-seeking thoughts. Your Spirit urges me to live God's way—to walk in faith and peace, not paralyzed by worry and fear. Lord, help me to recognize when anxious thoughts are battling for victory in my mind. I need to take notice of what is causing my stress and call out the lies of the enemy that feed my anxiety. Amen.

The mind governed by the flesh is death, but the mind governed by the Spirit is life and peace.
ROMANS 8:6 NIV

Rest in His Strength

Lord, I've tried doing things all by myself. I've trusted in my own plans and put my faith in my own initiative. Pride has convinced me that I've accomplished my goals with no one to thank but myself.

Father, please forgive my lack of trust in You and my arrogance for believing that I am the great mover and shaker. Because when I put my faith and trust in me, when things go wrong or I'm staring a situation in the face that I have zero control over, I have nowhere to turn. Teach me to rely on You. Teach me to wait for You. I have definitely made a mess of things in the past because I was impatient. Lord, my hope is in Your faithful love. Amen.

He is not impressed by the strength of a horse;
he does not value the power of a warrior.
The Lord values those who fear him,
those who put their hope in his faithful love.
Psalm 147:10–11 csb

Bringing Down Giants

Lord, Goliaths still plunder the lands You have given us. I combat the giants of fear, stress, and anxiety with alarming frequency. They scoff at me just as Goliath jeered at David for coming into the fight with five smooth stones.

But praise You, God! For You are still in the business of bringing down mammoth enemies in the face of overwhelming odds. David taught me that when I come against big problems in this world, I can face them bravely and say in faith, "I come against you in the name of the Lord Almighty!" You have promised to fight for me. I am not wading in alone. May others see my faith in You and Your care for me and recognize that there is a mighty God in heaven. Amen.

David said to the Philistine, "You come against me with sword and spear and javelin, but I come against you in the name of the Lord Almighty, the God of the armies of Israel, whom you have defied. This day the Lord will deliver you into my hands, and I'll strike you down and cut off your head. This very day I will give the carcasses of the Philistine army to the birds and the wild animals, and the whole world will know that there is a God in Israel."
1 Samuel 17:45–46 niv

Power through Weakness

Lord, I'm so relieved that I don't have to be strong for You. My weakness does not deter You. I don't have to "get it all together" to be used by You. In fact, my pride in my abilities is a stumbling block to Your power.

You lift up the humble who recognize their need for You. When I become smaller and weaker, then Christ in me becomes stronger and His power flows into my life. Otherwise, I might be tempted to take credit for things that You have done, Jesus.

I no longer want to complain about my weaknesses or see them as punishments from an angry God. Help me to rejoice in my weaknesses as Paul did, so I may live more powerfully through You. Amen.

*"My grace is all you need. My power works
best in weakness." So now I am glad to boast
about my weaknesses, so that the power of Christ
can work through me. That's why I take pleasure
in my weaknesses, and in the insults, hardships,
persecutions, and troubles that I suffer for Christ.
For when I am weak, then I am strong.*
2 Corinthians 12:9–10 nlt

My Provision

Lord, Your goodness flows freely through the flood-gates of Your abundance to those who look for and depend on You. Yet I can be so hardheaded in my belief that I am self-made. I emphasize the *I* in "I can do all things" and completely neglect the One who does the impossible on my behalf.

Lord, don't ever let me forget the second half of this verse: "through Christ who strengthens me." Oh Father, how my stress rises when I forget that I need Your strength to sustain me. Teach me to wait quietly for You, Lord, instead of pushing and forcing my own agenda. You are my provision—everything I'll ever need. In the name of Jesus, amen.

The LORD is good to those who depend on him,
to those who search for him. So it is good to
wait quietly for salvation from the LORD.
LAMENTATIONS 3:25–26 NLT

Work in Progress

Heavenly Father, I am beyond overjoyed that You don't give up on me! You've promised that I'm a work in progress until the day Jesus comes back. I can let go of my fears that my mess-ups might be too much for You. I am not too much for You, Father. My mess is not too big, and my problems are not too complicated for You.

Please soften the dried clay of my heart so that it yields to Your sculpting hand. Strengthen me to heed Your Holy Spirit's urgings. You are the Master Artist who would mold my heart into a thing of beauty when I surrender my will to Yours. Even when I falter, You're capable of redeeming my past and making me more like Jesus. Amen.

And I am certain that God, who began the good work within you, will continue his work until it is finally finished on the day when Christ Jesus returns.
PHILIPPIANS 1:6 NLT

Free Indeed

God, I can hardly believe my good fortune as Your child! I thought that my sentence was irreversible. I've sinned. I've messed up. I'm not going to deny it, because it's true. I've done wrong in Your eyes. My punishment was not misplaced. I wasn't wrongly accused or suffering from a case of mistaken identity. I was caught red-handed with the evidence stacked against me. I deserved Your condemnation. . . .

But then a miraculous thing happened. Instead of serving an eternal sentence, locked away from You for all time, You swung Your gavel and pronounced, "Forgiven!" My dead hope sparked to life. My mind could hardly follow. I'm free! Thank You, Jesus. . .You served my sentence for me. In Your precious name, amen.

For the wages of sin is death, but the gift of
God is eternal life in Christ Jesus our Lord.
ROMANS 6:23 NIV

Gather Me Close

Jesus, I'm struggling. I'm feeling vulnerable and invisible. My strength is waning, and my stress is winning. I'm not sure I can go on like this. Does anyone see me, God? . . . Do You? Have You forsaken me? My help seems far off. . .and yet, Father, I refuse to listen to this voice in my head whispering that I'm lost to You.

I know that my ways are not hidden from Your sight. You shield the weak ones of Your flock, and You are gentle with me when I need special care. Open my eyes to the ways You are caring for me even now, because You know all my needs. Jesus, gather me gently in Your arms and carry me close to Your heart. Amen.

He tends his flock like a shepherd: He gathers the lambs in his arms and carries them close to his heart; he gently leads those that have young.
ISAIAH 40:11 NIV

Overwhelming Victory

Lord, my enemy, Satan, wants me to believe that difficult circumstances can defeat me and steal my victory. But I will not allow my outward circumstances to rob me of my joy. Illness, stress, financial struggle, relationship difficulties. . .they will not drag me down into depression.

Jesus, You defeated sin and death once and for all. You handed me a victory. It's a done deal. My eternity with you is set. And Satan thinks this problem is going to defeat me? . . . I won a long time ago. *Nothing*—not disease or rejection or an empty bank account or failure or death—no, *nothing* can separate me now (or ever!) from the great love of God. Father, help me to live a victorious life. Your kingdom is here. In Jesus' name, amen.

Overwhelming victory is ours
through Christ, who loved us.
ROMANS 8:37 NLT

Knocked Down but Not Destroyed

Lord, the light of Jesus shines in me! I am a fragile vessel full of chips and cracks, and yet I contain the greatest treasure—the life that Jesus has given me. The amazing grace You have extended to me. . .the way You love me no matter what.

I may be hard pressed. I may be perplexed and hunted, but I am not crushed; I will not despair, and I am never abandoned by You, God. I refuse to give up even if I am knocked to my knees. The power that lives in me comes from You alone, God. No one could mistake this broken pot for a superpower. Thank You, God, for allowing me to see and know You in the face of Jesus. Amen.

We now have this light shining in our hearts,
but we ourselves are like fragile clay jars containing
this great treasure. This makes it clear that our great
power is from God, not from ourselves. We are
pressed on every side by troubles, but we are not
crushed. We are perplexed, but not driven to despair.
We are hunted down, but never abandoned by God.
We get knocked down, but we are not destroyed.
2 CORINTHIANS 4:7–9 NLT

Weapon-Wielding Woman

God, we are not defenseless in this world. We are far from having no protection. You've outfitted us with divine weapons for our fight in this war with eternal consequences. We can walk confidently, because the secret to our joy and security is that this war is already won.

Satan is a defeated foe who wants to keep us from living in the victory we possess today. Our enemy wants to keep us from knowing You and deceive us into believing lies about You. But You have given us faith as our shield against hopelessness, salvation as a helmet over our minds, the righteousness of Jesus as our body armor, truth to belt it all together, and Your Spirit and Your Word to engage the enemy in combat. Thank You, Father! Amen.

We are human, but we don't wage war as humans do. We use God's mighty weapons, not worldly weapons, to knock down the strongholds of human reasoning and to destroy false arguments. We destroy every proud obstacle that keeps people from knowing God. We capture their rebellious thoughts and teach them to obey Christ.
2 Corinthians 10:3–5 nlt

His Tender Call

Heavenly Father, I'm guilty of forgetting You as I pursued other loves in my life. I indulged my desires and ignored Your voice. At times I have consciously chosen sin over righteousness. I have led myself into a stressed-out mess of my own making.

And yet You didn't criticize me for my foolishness or judge me for my mistakes. Instead You chose to woo me back with gentle words. You led me to a quiet place to be alone with You—to focus only on You. Father, may I never again forget Your goodness to me. I desire faithfulness to You, who are ever faithful to me. I will praise You even in the wilderness, because out of Your deep love, You turn my troubles into hope. Amen.

"She decked herself with rings and jewelry, and went after her lovers, but me she forgot," declares the LORD. "Therefore I am now going to allure her; I will lead her into the wilderness and speak tenderly to her. There I will give her back her vineyards, and will make the Valley of Achor a door of hope. There she will respond as in the days of her youth."
HOSEA 2:13–15 NIV

Go with God's Plan

Lord, like this verse warns, a tornado of plans spins through my mind, battering my weary brain. But it is Your plan that comes to pass. All my striving is for nothing if I am living outside of Your good plans for me.

Relieve my stress as I open my hands and release my plans and problems to Your capable hands. The reality of my situation is that I don't have control—I never did. I only thought that I could make things happen all on my own. But everything that You set out to do, Father, happens in a big way. You have the power. Please help me to recognize Your plans and to lay aside the ideas that are mine and mine alone. Amen.

Many are the plans in a person's heart,
but it is the LORD's purpose that prevails.
PROVERBS 19:21 NIV

Know Him

God, it's stunning to realize that You, the God of all creation, the beginning and the end, want to know me and be known by me. You desired a relationship even with a stubborn people who often walked away from every good thing You offered them, instead running after whatever seemed like a good idea at the time. You called out and revealed Yourself. You pleaded with them to choose You over every other empty thing that captivated them.

Father, how much of my stress comes from walking right past Your outstretched hand that offers abundant life, and instead pursuing my own imaginations? I see now how much You miss me when I'm far from You. Keep me close, Father. Amen.

"I revealed myself to those who did not ask for me;
I was found by those who did not seek me. To a
nation that did not call on my name, I said, 'Here
am I, here am I.' All day long I have held out my
hands to an obstinate people, who walk in ways
not good, pursuing their own imaginations."
Isaiah 65:1–2 niv

A New Name

Father in heaven, the enemy whispers lies into my ear. He tries to defeat me by saying that I'm unworthy, unwanted, unloved, forgotten. He tells me that I'm nothing. He tells me that I'm hopeless.

But when my stress and anxiety begin to assault me, I choose to ignore his poisonous murmurs. Instead I choose to listen to Your Word. And You have promised me a new name. You say that I am Cherished. Loved. Known. Forgiven. Accepted. You say I'm Yours. And to the victorious, You promise a white stone inscribed with a special name from You. God, give me victory today, because I want to hold one of those precious white stones when You return. Amen.

To the one who is victorious, I will give some
of the hidden manna. I will also give that person
a white stone with a new name written on it,
known only to the one who receives it.
REVELATION 2:17 NIV

Compassionate Savior

Father, I've entertained the wrong impression of who You are. I thought that You condemned me, that I had to be perfect in order to be accepted by You. And I was so tired, stressed, and hopeless, because no matter how hard I tried to live up to Your expectations, in the end I always failed. I sinned. . .over and over and over. I told myself countless times that tomorrow would be different, tomorrow I would succeed, but I didn't.

But then I learned about what Jesus did for me— I was introduced to Your amazing grace! I learned that You don't look at me with censure and anger and impatience. You see me with compassion. Thank You, God, for Your grace. Amen.

When he saw the crowds, he felt compassion for them, because they were distressed and dejected, like sheep without a shepherd.
MATTHEW 9:36 CSB

Fill Me Up

Lord, when someone asks how we are, the answer is usually some tired version of stressed-out, worn-out, or down and out. But I'm done with hopeless living. I want to be filled with something better than frazzled emotions and a frenzied lifestyle. I want to be filled to the brim with You. I want to shout as the psalmist did, "My cup runneth over!"

Father, please fill me with Your love, grace, peace, and joy until they flow over my brim, delighting all those around me. May my spirit no longer be filled with complaints but instead overflow with all the fullness of the power of Your Holy Spirit. In Jesus' name, amen.

May the God of hope fill you with all joy and peace as you trust in him, so that you may overflow with hope by the power of the Holy Spirit.
ROMANS 15:13 NIV

God of My Details

Father, why do I allow worries and fears to run me ragged when I am resting in the care of the Good Shepherd—the One who loves me more than I could ever imagine or comprehend? You notice when a sparrow falls—a tiny, ubiquitous bird that everyone overlooks. . .everyone except You. And You take so much care that You've even numbered the hairs on my head.

Father, if You notice when a single strand slips from my head, no detail escapes Your watchful eye. You supply everything that I need, exactly when I need it. I want to trust You more. You're pleased to give good things to Your children, Father—including me. Thank You for taking care of every aspect of my life. In Jesus' name, amen.

*"Aren't five sparrows sold for two pennies? Yet not
one of them is forgotten in God's sight. Indeed,
the hairs of your head are all counted. Don't be
afraid; you are worth more than many sparrows."*
LUKE 12:6–7 CSB

Held by Him

Lord, a little child falls and scrapes her knee and then climbs into her papa's lap just to snuggle—she's content to sit wrapped in the gentle arms of someone who loves her, someone who will soothe away the pain. No matter our age, we all want the same things—comfort, the assurance that it will be well again. Sometimes we don't want words or advice or answers. . .we just need a hug, a connection that communicates love and caring and lets us know that we're okay.

Thank You, Jesus, that I can run into Your tender and strong arms when I need to be held. I find comfort in the assurance of Your love and compassion, Your strength and control. In Jesus' name, amen.

Blessed be the God and Father of our Lord Jesus Christ, the Father of mercies and the God of all comfort. He comforts us in all our affliction, so that we may be able to comfort those who are in any kind of affliction, through the comfort we ourselves receive from God.
2 CORINTHIANS 1:3–4 CSB

My Help

God, we humans are stubborn and independent creatures. I shake my head at my own pride. I find it far too difficult to admit my inadequacies to myself, so forget asking for help when I need it.

Father, show me where my stubborn pride has become a source of anxiety and stress. I know that, ultimately, my help comes from You. And I need to remember that sometimes You also work through the hands of my brothers and sisters in Christ. By rejecting their help, I am robbing them of the opportunity to bless others. Teach me to be humble and gracious in accepting help and blessings from others—and strengthen me, so that in return I can also assist those in need. Amen.

I lift my eyes toward the mountains. Where will my help come from? My help comes from the LORD, the Maker of heaven and earth. He will not allow your foot to slip; your Protector will not slumber. Indeed, the Protector of Israel does not slumber or sleep.
Psalm 121:1–4 CSB

My Good Father

Father, this world can feel like it's imploding with chaos. My stress clenches a tight fist around my heart because life seems dark, dangerous, and unpredictable. I question Your good intent and worry about a future that looks so uncertain.

But thank You, God, for the reminder that You are good. Darkness cannot dwell in Your unadulterated light. Your love endures forever, and You love me as Your own precious child. I belong to You, and You shelter me and fill me with unsurpassed peace and hope of an eternal future with You. I may not always understand Your ways, because I know they are infinitely higher than mine, but I trust in Your love and goodwill toward me. In Jesus' name, amen.

They celebrate your abundant goodness and joyfully sing of your righteousness. The LORD is gracious and compassionate, slow to anger and rich in love. The LORD is good to all; he has compassion on all he has made.
PSALM 145:7–9 NIV

I Am New

God, I'm here on my knees before You, the holy One, to confess that I am broken. What's worse is I look around and realize that the whole world is broken and torn up by sin—hatred and war, abuse of the weak, hurting families, extreme selfishness masquerading as love. I've tried to fix this brokenness, but the effort has left me depleted.

I can't make right the problems and suffering in this place any more than I can mend the sin in my own life. I need You, Jesus. When I surrendered to You, an amazing thing happened. You made me new! You reconciled all the wrongs and healed my broken places. Give me boldness in sharing this message of reconciliation with the broken people I meet. Amen.

*Therefore, if anyone is in Christ, the new creation
has come: The old has gone, the new is here! All this
is from God, who reconciled us to himself through
Christ and gave us the ministry of reconciliation:
that God was reconciling the world to himself in Christ,
not counting people's sins against them. And he has
committed to us the message of reconciliation.*
2 Corinthians 5:17–19 niv

Thrive beside the Water

Heavenly Father, the scorched and dusty wasteland around me seems hostile to tender new growth. I want to stand firm, but I don't always. Sometimes my brittle branches snap under the stress of my trials. But You have a better vision for me.

Father, when I twine my roots deeply into the living water of Your Word every day, I thrive in a parched world. My branches grow heavy with the succulent fruit of Your Spirit. Not only do I stand firm and prosper despite harsh conditions, but others are drawn to the fruit of my fellowship with You, Jesus. They see peace amid turmoil, joy in struggles, patience in hardship, and deep love. May my fruit draw others to Your living water that sustains me. Amen.

Blessed is the one who does not walk in step with the wicked or stand in the way that sinners take or sit in the company of mockers, but whose delight is in the law of the Lord, and who meditates on his law day and night. That person is like a tree planted by streams of water, which yields its fruit in season and whose leaf does not wither—whatever they do prospers.
Psalm 1:1–3 NIV

Cup of Blessing

Lord, in the psalms David often poured out his emotions to You. It's a comfort to know that I too can confide in You. My feelings are not too much for You to handle, and You're never shocked by what churns inside me.

But help me to remember that sometimes my overwhelming emotions can be deceiving. I need to fall back on the promises of Your Word to sustain me—that You are good, loving, faithful, merciful, and strong. Allow my thoughts to tarry on my blessings instead of my complaints. My enemy would distract me with my stress and disappointments, but I choose to believe that You are my cup of blessing, and I have a beautiful inheritance. Indeed the lines have fallen for me in pleasant places. Amen.

Lord, you are my portion and my cup of blessing; you hold my future. The boundary lines have fallen for me in pleasant places; indeed, I have a beautiful inheritance. I will bless the Lord who counsels me— even at night when my thoughts trouble me.
Psalm 16:5–7 csb

Not Too Much for God

Father, like Moses', my life has not been smooth. Circumstances beyond my control have stacked against me, and I've made some poor choices that have negatively impacted my life. People around me often step back from the complicated issues and stress that my life seems to add to theirs because they feel that I am just too much to deal with.

But You have shown me, God, that I am not too much for You. My problems and mistakes are never too big for You to turn around. You created me *on* purpose, and You made me *for* a purpose. Please take all my past experiences, good and bad, and redeem them for Your kingdom. Thank You, Jesus, for showing me that I matter in Your kingdom. Amen.

But I have raised you up for this very purpose,
that I might show you my power and that my
name might be proclaimed in all the earth.
EXODUS 9:16 NIV

Trade Worry for Praise

Father, why do I allow my worries and fears to take root in my thoughts? I know that when I dwell on my insecurities, they morph into anxiety, and my anxiety grows into stress.

Today, instead of allowing such destructive thoughts to get a stranglehold on my emotions, I choose to praise You for Your wondrous attributes. I come before Your altar, God, and I realize that *You* are my greatest joy. As I dwell on Your promises and the way You have kept Your word throughout the ages, I realize just how capable You are of managing every issue that causes me stress and how absurd it seems for me to wring my hands when You are in charge. My peace and hope rest in You. Amen.

*Then I will come to the altar of God, to God,
my greatest joy. I will praise you with the lyre,
God, my God. Why, my soul, are you so dejected?
Why are you in such turmoil? Put your hope in God,
for I will still praise him, my Savior and my God.*
PSALM 43:4–5 CSB

Keep On!

Father, this world questions my sanity when I say that I trust You. They look at one piece of the puzzle, one instant in time, one hurt, and say, "How can God care about us when He allows *this*?" But I know that You have a bigger picture in mind. You plan eternally. And I am going to stick with You even during the trials when I don't fully understand what You are doing. I'm not going to quit. I'm going to stay with You, God.

I'm putting all my eggs in one basket—Yours. Why? Because I see evidence of Your goodness all around me. I'm going to wait for You. I'm going to keep on trusting You for the rest of my life. Amen.

I'm sure now I'll see God's goodness in the
exuberant earth. Stay with GOD! Take heart.
Don't quit. I'll say it again: Stay with GOD.
PSALM 27:13–14 MSG

Lavish Love

Father, You're not holding back on us in Your great love story. You're not worried that we won't return Your affection or hedging Your bets by offering little of Yourself. Instead You've released the dam through Jesus. You've put it all out there.

You've offered *everything* to me—adoption into Your family, a place to belong. You've called me Your child. Not just an acquaintance or a vague friendship, You've folded me into Your family, into Your love. . . You've made me Your daughter. You turn adoring eyes on me and are delighted when I pull up a chair to Your table. Your Word says that there is no greater love than to lay down one's life for another—and You would know, because You did. Amen.

See what great love the Father has lavished on us, that we should be called children of God! And that is what we are!
1 John 3:1 niv

Rescued

Father, gratitude blooms in my heart each time I consider how You've rescued me and *continue* to rescue me from precarious positions of my own making. Sheep wander aimlessly and fall into dangerous places. Without a shepherd to guide them, they're easily scattered by whatever sight or taste captures their pleasure. And I am no better—easily distracted and often ignoring Your words of warning.

But Father, You *never* give up on me. You have vowed never to leave me or forsake me. You have promised to come and find me in my dark days and pull me from danger. You have accomplished the greatest rescue in the history of mankind by dying for me. Please transform my mess into a message of praise to You. Thank You, Jesus. Amen.

"For this is what the Sovereign LORD says: I myself will search for my sheep and look after them. As a shepherd looks after his scattered flock when he is with them, so will I look after my sheep. I will rescue them from all the places where they were scattered on a day of clouds and darkness."
EZEKIEL 34:11–12 NIV

An Inspiring Influence

Father, thank You for the friends You've gifted to me who make me a better person for having spent time with them. They're encouraging and caring, but they speak with truth from Your Word. They push me to be an improved version of myself.

Truly, my ultimate best friend is You. I am better in every way when I'm with You, Jesus. You gently and lovingly show me where I have been thinking or doing wrong, and You lift me up out of my stress and discouragement. You know everything there is to know about me—You've seen both my obedience and sin—and yet You still love me. Living Your way has brought joy and peace into my days. And I know You will never stop working on me! Amen.

You have stripped off your old sinful nature and all its wicked deeds. Put on your new nature, and be renewed as you learn to know your Creator and become like him.
Colossians 3:9–10 nlt

Revive Me

Lord, I was weary, worn thin, and beaten down—exhausted from facing another day of fighting the same old battles. My ragged emotions were running the show. But then I turned to Your Word. And I was reminded that You are my strength when I have none. You are my rest when I am tired. You are my peace when my emotions are battered.

When I come to Your scriptures, You gently lead me to the rest and restoration that I crave. You have refreshed and revived my perspective. I am not defeated, and I am not without hope. Thank You, Father, for providing me with what I need—both spiritually and physically. Teach me how to offer kindness and grace to others when they need refreshment too. Amen.

"I will refresh the weary and satisfy the faint."
JEREMIAH 31:25 NIV

I Give You My Cares

Father, my heart aches for the pain of this world. For the fears that crouch in wait and the anxiety that stalks our minds. For the sickness and pain and utter brokenness I see around me. Your creation cries out for a savior. When Jesus rode into Jerusalem, the people cried out, "Hosanna, save us!"

Father, You feel our hurts. You care for us. Jesus wept for us. He died for us. But the story doesn't stop there. You had an intricate and magnificent plan that has existed in You since before the beginning of time. Jesus rose from that grave. He walked out of that tomb. And He lives! I cast my anxiety on You because You love me. You have a plan. You didn't do what was expected and defeat the Roman government—You did something so much greater. You defeated death. You brought life, and with it. . . hope. Thank You, Jesus. Amen.

Cast all your anxiety on him
because he cares for you.
1 Peter 5:7 niv

Bear with Me

God, I'm sorry for internalizing my anxieties. You take such good care of me. You speak truth to me and show me what's right. You never allow me to get away with my sin, because it separates me from You. Yet, You are gentle in Your leadership. I see the ways that You bear with me in my weakness. Your patience. Your provision. How could I trust any other more than You, my Father? You've given me family to support me and teach me, Your Word to give me wisdom when I'm confused, Your Spirit so I'm never alone.

Smooth the stress from my mind like an unwelcome wrinkle as I lean on You. Father, help me to show Your patience and willingness to support those who are weak. Amen.

We who are strong ought to bear with the failings of the weak and not to please ourselves.
ROMANS 15:1 NIV

His Grace Is Sufficient

Father, I struggle with the stress of guilt—guilt over my mistakes and past choices, and even some of my present ones. It seems I fail more often than I'd like in this battle between right and wrong, sin and righteousness.

I used to hide from You because I didn't want to see a look of disappointment, or worse, anger and condemnation on Your face, Father. But everything has changed now. I came face-to-face with Your grace, and I finally understand that Your plan is not for me to be chained in performance-based Christianity, trying to buy Your favor with good deeds. Your love is already given! Your grace means that my guilt is no more. Jesus lived the righteousness that I could not. Thank You, Jesus. Amen.

But he said to me, "My grace is sufficient for you,
for my power is made perfect in weakness."
2 Corinthians 12:9 niv

Believe

Father, my stress is rising again. Fear is battling for my mind amidst the uncertain circumstances that are taking hold in our world. I must fortify my defenses against the enemy by staying in Your Word daily.

And so. . .I choose belief. I believe in You, God. I believe in Your power and that You oversee everything that goes on in this world. You're never thinking, *Oh, I didn't see that one coming. What am I going to do?* I believe in Your promises to be with me always, to fill my mind with peace, to love me, to provide for my needs. I believe what You have told me, Father, and so I place my full trust in You. And my heart is not troubled by the chaos around me. Amen.

"Don't let your heart be troubled. Believe in God;
believe also in me. In my Father's house are many
rooms; if it were not so, would I have told you that I
am going to prepare a place for you. If I go away and
prepare a place for you, I will come again and take
you to myself, so that where I am you may be also."
JOHN 14:1–3 CSB

Solid Ground

Lord, sometimes our emotions can take us on a roller coaster ride. Up. Down. Up and then roaring down again. Excitement can easily spiral into stress and despair when pressure mounts.

But, Father, I know that I don't have to stay on this roller coaster ride of negative emotions, because I know that You can rescue me from being tossed about on a wild ride. You can lift me out of the pit and give me a solid place to stand. You, God, never change. Never falter. Never fail. I put my trust in You. You are the rock where my feet find purchase as You lift me out of a pit of stress and despair. In the name of Jesus, amen.

He lifted me out of the pit of despair, out of the mud and the mire. He set my feet on solid ground and steadied me as I walked along.
PSALM 40:2 NLT

He'll Carry You

Father, I've carried my children around a lot. It's a pleasure to snuggle them close on my hip and no trouble to hold them. Especially when their little legs just can't keep up or they're feeling a bit defeated by the big world around them. I gather them up into my arms and let them rest while I do the work of keeping up for them.

Father, how comforting to know that You do the same for me. When I am feeling weighed down by the world, You pick me up and carry me through. It's not a strain on You. Help me to remember that my problems are not too big for You; and likewise, there's no care too small or inconsequential to bring to You. Amen.

"And in the wilderness. There you saw how the LORD your God carried you, as a father carries his son, all the way you went until you reached this place."
DEUTERONOMY 1:31 NIV

Miraculous Multiplication

Father, sometimes I worry that there just won't be enough—enough time in the day for all the work that needs to be done; enough money to pay the bills, buy groceries, and pay for those braces my daughter needs; enough energy to care for my family.

Thank You, Jesus, that You have great compassion for us humans who worry about not having enough. Please keep this lesson in my mind: when I give things to You, You are capable of supernatural multiplication, just like You multiplied the fish and bread until every need was met. And You can meet my needs as well. You are my great Provider. Please show me where I can be Your hands and provide for someone in need. Amen.

Then he took the seven loaves and the fish, and when he had given thanks, he broke them and gave them to the disciples, and they in turn to the people. They all ate and were satisfied. Afterward the disciples picked up seven basketfuls of broken pieces that were left over.
MATTHEW 15:36–37 NIV

Listening Ear

God, increase my faith. May I notice all the ways You have answered my prayers in the past and every little detail You have orchestrated in my life. Like the man told Jesus, "I believe—help my unbelief." Help me to see that You care about every piece of my life.

Father, thank You for watching over me. It soothes my fears to know that You are listening for my prayers. You care about the medical test results I'm anxiously awaiting. You care about my strained relationship with my child. You even care about my misplaced phone. I'm not merely shouting my problems into the cosmos—You pay attention to my life because I'm so very important to You. You listen to my stresses and replace my fears with peace. Amen.

The eyes of the LORD are on the righteous,
and his ears are attentive to their cry.
PSALM 34:15 NIV

First Place in My Heart

Father, You've told me that only one thing can have first place in my affections. There are no ties for the winner of my heart. And I want to be singularly devoted to You. Yet I worry about money. How can I make more? Will I have enough? Should I be saving more? And how can I spend less?

The worries mount, and stress nibbles at the corners of my peace of mind. But I trust You, Father, to care for me. I don't want the pursuit of money to take first place in my affections. Help me to make wise choices, and give me generosity of heart to serve others with the resources I have. The more I submit my finances to You, the more evident Your provision for me becomes. Amen.

"No one can serve two masters. Either you will hate the one and love the other, or you will be devoted to the one and despise the other. You cannot serve both God and money."
MATTHEW 6:24 NIV

Path Finder

Lord, the world questions Your power when You don't just step in and fix all the situations in this life that go haywire. They want to know whether You're really out there or just a myth or fantasy figment of our imagination. . .or if You have no will or strength to change things here on earth.

But I know there are things I can't see—things I don't yet understand. But You do, and I trust in You with my whole heart. I will not rely on what little sense I can make of confusing situations but rest my mind on Your great love for me. Give me wisdom and direction in this broken world. I know You have laid out the best path for me. Amen.

Trust in the LORD with all your heart; do not depend on your own understanding. Seek his will in all you do, and he will show you which path to take.
PROVERBS 3:5–6 NLT

A Way Out

Lord, I know You don't set Your laws because You are a killjoy, a hater of fun, or an overbearing dictator. You set up boundaries to protect me. . .because You love me. And just as dangerous things happen when a river floods and spills over its banks onto the land around it, dangerous and heartbreaking things happen when I ignore the boundaries You have placed around my life.

Father, show me where I am ignoring Your guidelines, and give me strength to resist the urge to do things that are outside of Your law—and not because I think that my good behavior will gain me heavenly brownie points. I want to obey because I love You with my whole heart for all the ways You love me so completely. Amen.

The temptations in your life are no different from what others experience. And God is faithful. He will not allow the temptation to be more than you can stand. When you are tempted, he will show you a way out so that you can endure.
1 CORINTHIANS 10:13 NLT

Sheltered by His Wings

Dear Father, I'm having one of those days where I just want to crawl back into bed and cover my head and hide from the world and my feelings. It all seems so overwhelming, and I feel so weak and worried. Thank You for the ability to hide under Your wings instead; Your strength and reassurance calm my soul in a volatile world.

After just a short time of being nurtured by Your words and truth, I am ready to crawl out from under Your feathers and face the day—strengthened by the promises I believe. I will lean into Your strength. When the winds of worry howl against me, Your faithfulness will spread over me like a broad, impenetrable shield. In Jesus' name, amen.

He will cover you with his feathers, and under his wings you will find refuge; his faithfulness will be your shield and rampart.
PSALM 91:4 NIV

My Soul's Anchor

Lord, I come before You to worship as I am standing in the wake of a storm. As the storm was raging and I was being blown about, I started to lose my bearing. But You have been faithful and steadfast, you have anchored my soul—firm and unmoving. As the winds blew strong and the waters rose, You rescued me and pointed me due north when the horizon was cloaked in darkness.

Thank You, Father, for Your ever-present protection. My hope is in the life that You give—the grace, forgiveness, mercy, love, and abundant, forever life. And this hope steadies me when the climate around me becomes dark and dangerous. I know that my soul and my eternity rest securely with You, Jesus. Amen.

We have this hope as an anchor for
the soul, firm and secure. It enters the
inner sanctuary behind the curtain.
HEBREWS 6:19 NIV

Sure as the Sunrise

God, I come before You both anticipating the great things You will do in my life and in the world around me, and simultaneously suffering from doubt that You would show up in my mess as I wait in the cloaking darkness. I'm so tired. And fear slithers into my soul because I can't yet see Your movements in this enfolding blackness. How long, Lord, until You come?

Loving and merciful Father, please forgive my weak faith. I know You will give me strength and courage each day, each hour, and each moment as I need it. Just as the night watchman is convinced of the advancing sunrise, I too am sure that You hear me and will answer. May everything I experience bring glory to Your name. Amen.

I wait for the LORD, my whole being waits,
and in his word I put my hope. I wait for the
Lord more than watchmen wait for the morning.
PSALM 130:5–6 NIV

Heaven's Dew

Father, I admit that my life doesn't feel very blessed right now. I'm struggling to see the good through the blinding haze of bad that obscures my vision. Things aren't going my way; in fact, invisible forces seem to be moving circumstances against me.

But, Father, I know that Your blessings for me are still here. And while You may not be blessing me with material things that I wish I had, You have blessed me with Yourself. Your Word says that You are a friend that sticks closer than a brother. And I have experienced Your amazing friendship. I believe that You want to bless me, Father. Please reveal to me any hidden sin that may be hindering Your good blessings for me. And thank You for sticking with me always. Amen.

May God give you heaven's
dew and earth's richness.
Genesis 27:28 niv

He Understands

Father, I've been lonely. My emotions cry out that no one understands what's going on in my life. My family doesn't get the stress I'm under, and I feel as if there's no one I can talk to. But I know that You are with me always. And that You *do* understand, regardless of how I feel.

Jesus, You walked this lonely earth. You were misunderstood, mocked, abused, beaten, betrayed, and killed. You cried real tears in this world. You understand me completely and fully, because You walked a more treacherous road than the one I tread. I ask You to take my troubles and replace them with Your peace. I don't want to carry this load of baggage anymore. Thank You, Jesus, for listening, for understanding, for saving me. Amen.

Pile your troubles on GOD's shoulders—
he'll carry your load, he'll help you out.
He'll never let good people topple into ruin.
PSALM 55:22 MSG

Bursting Hope

Father, I have to keep the bigger picture in mind when I'm feeling overwhelmed with life. I was a sinner destined for eternal death before I met Jesus. And nothing that I could do myself could save me. I was in a hopeless and dire situation. But Your mercy saved me. You chose to give Your Son in my place so that I can experience life and hope in salvation.

Thank You, Jesus, for Your sacrifice! When life seems too much, I need only to remember that this world is fleeting. My cares and troubles here won't last forever, because Jesus has overcome the world. I have lasting victory no matter the battles I might lose today. My future is one of bursting hope! In Jesus' name, amen.

He saved us, not because of righteous things we had done, but because of his mercy. He saved us through the washing of rebirth and renewal by the Holy Spirit, whom he poured out on us generously through Jesus Christ our Savior.
Titus 3:5–6 NIV

Ultimate Sacrifice

Father, sometimes I feel unseen. Unnoticed. My suffering doesn't move anyone around me into action. It makes me feel alone. Isn't anyone willing to help me?

I have read in scripture that my help comes from You. My spirits lift as I realize that even if no person aids me or offers comfort, my Good Shepherd already has. It is no trivial thing You have done for me. It is the biggest, the *hardest*, sacrifice anyone could ever make on my behalf and the grandest gesture of love I will ever receive—Jesus, my Good Shepherd, You laid down Your life for me. It wasn't taken from You. You decided to give it up—for me. In the precious name of my Shepherd, Jesus, amen.

*"I am the good shepherd. The good
shepherd lays down his life for the sheep."*
John 10:11 niv

Thirst Quencher

Father, this life has a way of wringing me out, leaving me feeling depleted, parched, dried up. But I praise You that I don't have to wallow in that withered state. I know just where to go—to the well of Living Water.

Father, Your Holy Spirit fills me up until I am overflowing with Your fruits. I know that You are the only well that will never run dry, my source of forever life. I've tried other things, God—money, success, family—but they aren't enough. They don't fully satisfy this driving thirst for You. I want more of Your Spirit. Revive me with Your living waters. Father, with You I will never need another source to quench this desire inside me. Amen.

Jesus answered, "Everyone who drinks this water
will be thirsty again, but whoever drinks the water
I give them will never thirst. Indeed, the water I
give them will become in them a spring of
water welling up to eternal life."
JOHN 4:13–14 NIV

He Never Sleeps

God, I rest securely in the knowledge that there are no surprises for You in my life—or in the vast entirety of Your creation. Your Word promises that You are ever watchful, never sleeping, always vigilant. I can rest in peace knowing that You are guarding my life at all times. Never caught unaware. Never shocked. Never unsure. Never needing to "wait and see."

You know all. You see all. Everything past, present, and future is within Your scope of vision. And knowing this brings the greatest comfort and peace to my life. How can I allow worry to rise within me when the eternal, omnipotent, omniscient God of everything that ever was, is, and ever will be is watching over me? Thank You, God, for Your constant care. Amen.

Indeed, he who watches over
Israel will neither slumber nor sleep.
PSALM 121:4 NIV

My Strong Tower

God, I've seen the ruins of ancient castles from dangerous times gone by. Thousands of squat stones laid one upon another to form sturdy, protective walls where the people of the land could take shelter when their enemies attacked.

Father, I need a safe place to hide when my enemy is attacking—a place that has proven itself to be strong and impenetrable. You are that strong place for me, God. I know that You will take care of me because You are faithful. Your Word says that You are a strong tower I can run to when I'm afraid. Shelter me from the enemy's fiery darts. They're finding their marks from all angles today. Strengthen me with Your armor so I can face these spiritual attacks. Amen.

But the Lord is faithful, and he will strengthen you and protect you from the evil one.
2 Thessalonians 3:3 niv

Evidence of Things Not Seen

Father, sometimes it's hard to keep my faith focused on my expectant hope. I get discouraged and stressed out by the reality that is bearing down on me, the hurts I feel, the stress that tenses me, the fears that smother, and I lose sight of where my hope rests.

My hope rests in a coming reality that is as sure as the morning sunrise. I can't see it yet, but I know with certainty that I will spend eternity in a wondrous place with You—a place void of pain, empty of sin, and filled with Your comforting light. I know that I live under Your grace. I know that You love me greatly. I can't see it now with my eyes—I'm living in a world of "not yet"—but my hope is securely fastened to this fantastic future. Amen.

Faith shows the reality of what we hope for;
it is the evidence of things we cannot see.
HEBREWS 11:1 NLT

Alpha and Omega

Lord, sometimes uncertainty can swipe my feet right off the solid ground I thought I was standing fixedly on. I may not be able to feel certain about how things in my life are going to turn out—I may become ill, I may lose my job, my child may make a huge mistake—but I can be sure of one very important thing: You, God, are never uncertain about how anything is going to end.

You hold the past, present, and future in Your capable hands. You are the beginning of all things and the end. You are the Almighty. Father, give me peace as I bathe my stress-filled mind in the knowledge that You are the Alpha and the Omega. Amen.

"I am the Alpha and the Omega," says the Lord God, "who is, and who was, and who is to come, the Almighty."
REVELATION 1:8 NIV

He Fights for You

Lord, whenever I'm feeling anxiety's crushing fist tightening around my chest, help me to remember that this battle is not mine. . .it's Yours. My stress relaxes its chokehold on my life when I realize that it's not up to me to force things to happen. When I am faithful to You, seek Your will, study Your Word, and submit to You, You fight the battle for me.

The Israelites weren't victorious in taking the stronghold city of Jericho because they went out and scaled those intimidating walls and trained day and night with sword and shield; they won because they obeyed Your words to them. . .and then You crushed the walls standing in front of them. Father, please fight this battle for me. Amen.

This is what the Lord says to you: "Do not be afraid or discouraged because of this vast army. For the battle is not yours, but God's."
2 Chronicles 20:15 niv

Focus on the Father

Father, I feel exhausted by the frenzy of activity that is my life. I'm always in a hurry, constantly weighing what things I have room for in my day.

Please help me to prioritize my time in a way that glorifies You. I feel less stressed when I pause my day to spend time with the most important friend I have. I'm stopping the mad rush right now to still my rampant thoughts and restless body and think about what it means to my existence that You are God. You hold me together when I'm losing it. You bring peace to my panic. Calm to my crazy. Faith to my fear. Thank You for being all that I am not. In the name of Jesus, amen.

He says, "Be still, and know that I am God;
I will be exalted among the nations,
I will be exalted in the earth."
PSALM 46:10 NIV

No Hiding Places

God, Your Word is full of people who tried to hide from You. Jonah sailed off in a boat; Adam and Eve snuck off to the bushes; and Elijah hightailed it to a cave. And I too have done my share of trying to keep things from You.

I'm not sure why any of us thought hiding would work. I know that Your presence fills the entire universe. There's nowhere I can go that You can't find me. And yet, when I don't want to face You with my sin, my fear, my disobedience, I try to run the other way. But I know that no action of mine could ever separate me from Your love. Your grace covers even my worst moments. Thank You, Jesus, for finding me. Amen.

"Who can hide in secret places so that I cannot see them?" declares the LORD. "Do not I fill heaven and earth?" declares the LORD.
JEREMIAH 23:24 NIV

Share the Love

Father, I wonder sometimes if I'm getting this Christian walk thing wrong. Am I doing what You would have me do? Am I missing Your voice? Leaving opportunities on the table? My life feels, well. . .small. Despite my devotion to You, is my little life really that meaningful in Your kingdom?

But then I read Galatians, and I realize that You really did make it very simple. I need to love others—in big ways, in small ways, in easy ways, and sometimes in hard ways. It's not complicated calculus or mysterious deception. You want me to live my life loving others as You have loved me. . .to go around doing good works so that others will be drawn to the light of Your goodness. Show me who needs a little love today. Amen.

For the entire law is fulfilled in keeping this one command: "Love your neighbor as yourself."
GALATIANS 5:14 NIV

He Opens Minds

Heavenly Father, my heart is burdened for my loved ones who do not see You. I want to pester them and get on my soapbox and preach about Your love and grace. I want to provide the key that unlocks their chains and releases them from their tormentors.

But my burden is lifted when I remember that You alone have the key to open their eyes and to give them ears to hear. It is not my role to be their Holy Spirit but to be a reflection of Your love and a witness to Your resurrection through the peace and grace You have given me, as I continually pray for those dear to my heart. Draw them close to You, Lord, and open their minds to understand. Amen.

Then he opened their minds so they could understand the Scriptures. He told them, "This is what is written: The Messiah will suffer and rise from the dead on the third day, and repentance for the forgiveness of sins will be preached in his name to all nations, beginning at Jerusalem. You are witnesses of these things."
LUKE 24:45–48 NIV

Change a Single Life

God, what could I possibly do to impact the brokenness, pain, and hopelessness of this world? I'm only one person, and I'm not a particularly rich or impressive one at that. I live a normal life, and yet I feel an underlying anxiety over the depressing state of our world and the pain I see on faces around me.

But I realize after reading this scripture from Hebrews that I can share. I can lift a burden—even if it helps only a single person. And tomorrow I can help another. You're so pleased with my sacrifice of doing good in this hurting world. Today I will worship You by chatting for a while with my lonely, elderly neighbor. The feelings of helplessness are lifting from my heart already. Thank You, Jesus. Amen.

Make sure you don't take things for granted and go slack in working for the common good; share what you have with others. God takes particular pleasure in acts of worship—a different kind of "sacrifice"—that take place in kitchen and workplace and on the streets.
HEBREWS 13:16 MSG

Righteousness by Faith

Father, sometimes I wonder what You're up to. Your ways don't always make sense to me. I'm in awe of Noah. He lived in a desert, cocooned in warm sunshine. And You told him to build a giant boat because a flood was coming. Noah had no evidence of this impending disaster except His faith in Your words. And he worked tirelessly for years, much to the mocking delight of his neighbors, to build that boat. He was obedient despite whatever he may have thought about the probability of a flood.

I wonder, in the midst of Your warnings, do I laugh and keep right on doing what I've been doing? Or do I believe with all my heart and obey You. Father, help me leave this gnawing doubt and selfishness to follow You wholeheartedly. Give me faith like Noah! Amen.

It was by faith that Noah built a large boat to save his family from the flood. He obeyed God, who warned him about things that had never happened before. By his faith Noah condemned the rest of the world, and he received the righteousness that comes by faith.
HEBREWS 11:7 NLT

Sharpen Me

Father, I've felt a prickling unease slide up my spine when I'm with certain people. Some are negative, critical, and doubtful about everything and everyone they encounter. I've also realized that others' gossip loosens my lips too—and before I know it, I'm discussing my friends' private lives and handing down judgments I've no business making. I find myself sliding into ungodly behavior when I spend time with these people.

Father, please forgive me for not keeping my guard up against gossip and criticism. Help me to gently limit my time with those who don't encourage me to behave in a godly way and to be intentional in shining for You when I'm with them. Send me a friend who will sharpen me to live better. And help me to be a friend like this to others. Amen.

*As iron sharpens iron, so one
person sharpens another.*
PROVERBS 27:17 NIV

Content No Matter What

Lord, I like peaceful decor, comfortable furniture, and luxurious rugs. I enjoy being surrounded by beautiful treasures I've found. And sometimes I see something that costs more than I should spend, but my mind stays a bit obsessed with how much I want it. I try to replace it with a different thought or remind myself that I don't need it, but I keep picturing it decorating my space. And too often I give in and buy it.

Father, teach me contentment. And not just with my things, but in difficult circumstances too. Hard times come, and I just want an escape. But You sustain me, Father. You fill up the emptiness of my dissatisfaction. Help me to be truly content, no matter what. In Jesus' name, amen.

I don't have a sense of needing anything personally. I've learned by now to be quite content whatever my circumstances. I'm just as happy with little as with much, with much as with little. I've found the recipe for being happy whether full or hungry, hands full or hands empty. Whatever I have, wherever I am, I can make it through anything in the One who makes me who I am.
PHILIPPIANS 4:11–13 MSG

On Guard

God, why do I so easily forget that I'm living in a battle zone? Spiritual forces are at war in this world, and souls are on the line. Eternity hangs in the balance for some, and I need to fight. Help me to see anxiety and stress as weapons of the enemy. He wants to see fear wash white across my face and doubt spill darkness in my eyes when I come up against him.

Father, keep me vigilant in watching for his attacks, and help me stand firm in faith. When fear mounts, I know You will be my courage. Give me wisdom in recognizing sin and temptation for the lethal attacks against Your kingdom that they are. Gird me with strength as I face this day. I rest in Your inexhaustible power. Amen.

Be alert, stand firm in the faith,
be courageous, be strong.
1 Corinthians 16:13 csb

Hold Me Up

Father, as a child in need of help, I ran to my mom or dad to dry my tears and soothe my scraped-up knees or bruised emotions. And I knew that when I brought my pain to my parents, they wouldn't turn me away. Instead they would be moved by love to wrap me in a hug and take my little fingers to lead me through whatever problem had shoved me down. I rested in the comfort of security as I was cradled in the loving guidance of my parents.

Father, sometimes as a grown-up, I try to be too self-sufficient. I forget who to turn to with my stressed-out anxiety over the problems I have. Father, You alone promise to hold me up. May I never forget to run to You. Amen.

Don't be afraid, for I am with you. Don't be discouraged, for I am your God. I will strengthen you and help you. I will hold you up with my victorious right hand.
ISAIAH 41:10 NLT

Perfectly Peaceful

Lord Jesus, Peter stepped out of a boat to stand on water because he saw You and what was possible through Your power. And he did it! He stood on the waves beside You. Yes, he looked away and began to sink, but what a miraculous example of the amazing things that are possible when our minds are fixed on only You.

If I can focus my thoughts on Your Word and resist the distractions of my stress-filled emotions, if my trust in You can be steadfast and never wavering, You will keep me in perfect peace—even in the middle of an uncertain, hectic, scary life. I trust You, God. I trust Your goodness and strength. I trust Your love and mercy. Keep my thoughts locked on You. Amen.

You will keep in perfect peace all who trust in you, all whose thoughts are fixed on you!
ISAIAH 26:3 NLT

Seek His Wisdom

Father, how often have I wondered and worried about what to do, which choice was the right one? Or if a path even exists that leads through my knotted mess. I've fretted and wrung my hands and probably gained more than a few gray hairs agonizing over what I should say or do—or not do. And all that anxious energy I've expended wearing out my floorboards at midnight is a complete waste. I spark no insight from the deaf walls huddled around me.

All I need to do is ask You. You won't criticize or reprimand me for my questions. Instead, You will give Your advice generously. Father, I need Your wisdom. Show me what to do. In Jesus' name, amen.

If you call out for insight and cry aloud for
understanding, and if you look for it as for silver
and search for it as for hidden treasure, then you
will understand the fear of the LORD and find the
knowledge of God. For the LORD gives wisdom;
from his mouth come knowledge and understanding.
PROVERBS 2:3–6 NIV

All That Glitters

Lord, it seems incredible that the people of Israel, whom You led out of slavery in Egypt through impressive and powerful miracles, could abandon You to worship something cast in gold—utterly powerless, a creation of their own hands. But, Father, I know that sometimes things that glitter catch my attention and distract me from You as well. And when my focus is absorbed into meaningless things, it's no longer centered on You. And when my thoughts stray from You, it's easy to start making poor choices, just like the Israelites did.

Father, keep me from idols—glittery things that have no power in this life. Show me where I've made something more important than You. Keep my mind focused on You, the living and powerful God. Amen.

*Then Aaron took the gold, melted it down,
and molded it into the shape of a calf. When the
people saw it, they exclaimed, "O Israel, these are
the gods who brought you out of the land of Egypt!"*
EXODUS 32:4 NLT

Close By

Heavenly Father, my spirit feels crushed under the pressures and cares of this world. My daily worries stifle me, and they seem only to be growing more suffocating. Am I going to lose my job? Are my kids doing well enough in school? How do I care for my elderly parents while I'm raising my kids? What am I going to do without health insurance if someone in my family gets sick? The stress presses in from all sides.

Father, instead of indulging in a panic attack, I choose to spend time in Your Word. And a peace eases the crushing force of worry. You promise that You are close to me when my heart is broken and that You will save me when my spirit is under attack. Thank You, Jesus, for Your saving power. Amen.

*The LORD is close to the brokenhearted
and saves those who are crushed in spirit.*
PSALM 34:18 NIV

The Gift of Peace

Lord, I live by faith and not by fear. The enemy tries to scare me with things I cannot control, but I choose faith over fear. You have given me a peace that I cannot always comprehend. And the peace I have from You is a gift this world cannot understand.

When others are running around in hysteria because of a crisis, I am filled with peace. When others have no hope in a tragic loss, Your peace washes in like the tide. No insurance policy, government assurance, or amount of money in the bank can imbue me with the saturating peace of mind that comes from knowing You, Jesus. Thank You for giving me peace, and help me to remain faithful in all circumstances. Amen.

I am leaving you with a gift—peace of mind and heart. And the peace I give is a gift the world cannot give. So don't be troubled or afraid.
JOHN 14:27 NLT

Do-Gooder

Father, sometimes my mounting anxiety and stress come from living a life that is too self-focused. Forgive me for getting too distracted by my own needs and forgetting the needs and hurts of those around me.

Remind me today that You have a job for me to do—kingdom work that You have prepared especially for me. Show me today what work You have for me to do. Whether it's picking up groceries for my neighbor or watching a friend's kids, give me a nudge when I see a job that You've prepared for me. And, Father, as I extend my focus beyond myself, my perspective is often corrected, and I see my life for the blessing that it is. As a result, my stress is spiritually relieved. Amen.

For we are his workmanship, created in Christ Jesus for good works, which God prepared ahead of time for us to do.
EPHESIANS 2:10 CSB

Self-Care

Heavenly Father, am I neglecting or mistreating this body, this temple, You've given me? My stress levels have been high, and I know I haven't been taking care of what I've been blessed with. You are not a cruel task master who demands I work around the clock with no relief. You want me to experience rest.

It's been said that sometimes the holiest thing you can do is take a nap. I am run down and in need of physical rest so that I can help others. Father, help me to eat healthy foods, exercise, and sleep so I'm not too exhausted to shine as a light in this world. Thank You, Jesus, for the price You paid for me. I'm going to take better care of Your temple. Amen.

Don't you realize that your body is the temple of the Holy Spirit, who lives in you and was given to you by God? You do not belong to yourself, for God bought you with a high price. So you must honor God with your body.
1 Corinthians 6:19–20 nlt

Working for the Master

Lord, I get grumpy sometimes, and I don't feel like doing things for other people. The enemy whispers, *What have they ever done for you; It isn't fair for you to have to do this; Your boss expects too much of you; Your family doesn't appreciate your sacrifice.* But, Lord, I know that these self-pitying thoughts are not from You.

My stress melts away when I use every moment of my day to worship You. Every job I do—whether it's a big project at work or washing the dishes after dinner—is an act of worship to You. I will work willingly and dedicate every task to bringing You glory through a happy heart of worship. May others see my attitude and be drawn to Your light. Amen.

Whatever you do, work at it with all your heart,
as working for the Lord, not for human masters.
COLOSSIANS 3:23 NIV

Pure Light

Father, I don't always understand the things that happen in this world. It would be very easy when I'm hurting or I see someone who is suffering, to question Your goodness, Your motives, Your ability to control the situation. But instead I choose to trust You despite the heartbreaking results of sin I see around me.

You promise that You are light and only light. You aren't streaked with darkness or hiding ulterior, selfish motives. You are light—bright, piercing, clean light. And there is absolutely no darkness in You. I may not be able to understand the intricate, eternal plan in all its vast details, but I can trust in Your unadulterated goodness and love for me. Amen.

This is the message we have heard from
him and declare to you: God is light,
and there is absolutely no darkness in him.
1 John 1:5 csb

Friends for Troubled Times

Father, I've been down and feeling stressed and anxious lately. But I choose to stop and thank You right now for the loyal friends You've given me to walk alongside me through this life. They love me no matter what and always direct me to Your Word when I'm saying or doing things that aren't pleasing to You. And when I'm having a rough time or my car breaks down or I lose my job or my child is sick or I'm sick—they lend a hand to help me get through. My friends are truly Your hands and feet in the Church. And my family includes some of my closest friends, Jesus. Thank You for sending me help in the form of amazing friends. Amen.

A friend loves at all times, and a
brother is born for a time of adversity.
PROVERBS 17:17 NIV

You Loved Me First

Father, I'm worn out. I've been working so hard to get into Your good graces, to make You pleased with me. And then I read Your Word and a realization crashes over me, bathing my stress-beaten mind in peace. . . .

You loved me first! I can't work my way into Your affections. And I don't have to! You have *always* loved me. Fully. Completely. Deeply. Unconditionally. Eternally. Your love is so great that Jesus took a harsh punishment that was meant for me. He absorbed Your wrath so that now when You look at me, You see only the pristine, shining righteousness of Jesus. How foolish of me to think that I could add to the work of the cross. Your perfect love drives away all my fears. Amen.

Such love has no fear, because perfect love expels all fear. If we are afraid, it is for fear of punishment, and this shows that we have not fully experienced his perfect love. We love each other because he loved us first.
1 John 4:18–19 nlt

Empowered

Father, thank You that I don't have to do this Christian life on my own! I've tried, and I've failed miserably to do the right thing. My spirit is willing, but my flesh is oh so weak.

But I will not let my anxiety over my failures stomp me into the mud. I have a supernatural power source: Your Holy Spirit lives in me. I can hardly comprehend that the same power that created the universe, the same magnificent power that both drives hurricanes and stills storms with a word—the fullness of God's mighty power—lives in me in the form of Your Spirit. All I need to do is ask for Your help. You give me the strength to overcome. And even when I fall, Your grace catches me. Amen.

But you will receive power when
the Holy Spirit comes on you.
ACTS 1:8 NIV

Deep Well of Strength

Heavenly Father, I'm exhausted. The weight of care and worry hang heavy on my body. My emotions are wrung out like yesterday's dish rag. My heart is tired, and I feel empty inside. I'm not sure I have anything left to give. I've been trying to give from my own well. And I realize that I'm scraping out the last of my reserves like a hungry child digging at an empty peanut butter jar.

Father, I need to tap into Your strength reserves. Your power is unlimited, and I'm asking You to revitalize me. Through You I can give and not grow weary. I can serve and not become faint. I'm going to rest my care-worn heart in the hope I have that You've got this, God. Amen.

But those who hope in the LORD will renew
their strength. They will soar on wings like
eagles; they will run and not grow weary,
they will walk and not be faint.
ISAIAH 40:31 NIV

Your Will Be Done

Father, I'm facing something difficult and frightening that I'd much rather not have to endure. I'm asking, as Jesus did, that if You would, please deliver me from the pain. I know that You are a mighty and all-powerful God who is more than capable of moving on my behalf and changing my circumstances in a blink. But, Father, I also know that You are a good and loving God who is working out a plan for my good.

So I trust You, good Father, enough to say, even if Your don't remove these circumstances from me, I will still love and praise You. I will still trust You. I will still put my faith and hope in You. Nevertheless, not my will, but Yours, be done. Amen.

> *"Father, if you are willing, take this cup away from me—nevertheless, not my will, but yours, be done."*
> LUKE 22:42 CSB

Living Hope

Lord, at times life drags me down because I've put my faith in foolish things. Forgive me for searching out something to compensate for my lack of faith in Your ability to handle this situation on my behalf.

But You have given me a new hope. To hope is to trust or believe that something will happen, and I realize that I had placed my hope in worldly things—money, my own abilities, my government, my family. Help me to remember that my hope is rooted in Your great mercy, in the resurrection of Jesus. Because He died and rose again on the third day, I have hope for today and for my eternal future. In the name of Jesus, amen.

Praise be to the God and Father of our Lord Jesus Christ! In his great mercy he has given us new birth into a living hope through the resurrection of Jesus Christ from the dead.
1 PETER 1:3 NIV

Calm My Anxious Fears

God, sometimes my fears swell inside of me like a surging tide, threatening to overwhelm me with deep waters. Life seems dark, frightening, and uncertain—teetering on a razor's edge. I don't know how the world can face another day without You, Father.

When I am afraid, I come to You for peace, hope, protection, and love. You have promised never to leave my side. Help me to remember that prayer and thanksgiving are the antidotes to my anxious fears. Wash my mind in Your peace that is beyond understanding. Bolster me with an attitude of power and love, because You are able, You have called me by name, and I belong to You. I walk in the power of Your Spirit. . .whom shall I fear? Amen.

For God has not given us a spirit of fear and timidity,
but of power, love, and self-discipline.
2 TIMOTHY 1:7 NLT

He Can

Lord Jesus, the world says that You were just a man—a charismatic teacher who rattled the status quo and forged unforgettable history. But my heart cries out that there's so much more to Your story. That You were no mere mortal. My heart sings with the knowledge that You didn't stay in that grave!

I believe, Jesus, that You are God's beloved Son, the God-man who walked blamelessly and died in my place to rise again and be seated beside the throne of God. My heart shouts as Mary did to the disciples three days after the horror of Your death—Jesus is alive! Lord, crush every doubt and let me live each moment in the breathtaking power of belief. Amen.

"Have mercy on us and help us, if you can."
"What do you mean, 'If I can'?" Jesus asked.
"Anything is possible if a person believes."
MARK 9:22–23 NLT

Beware the Enemy

Lord, You warn us to be alert because our enemy, the devil, prowls around like a lion looking for someone to devour. The saying "know your enemy" holds true to my Christian walk as well. Satan wants only to steal and kill and destroy. And he lies. I need to know his tricks inside and out so I don't fall prey to his wiles. He's been lying from the beginning of time.

Thank You, God, that I can always tell when Satan tries to lie to me because my thoughts won't match what You say to me in Your Word. Keep me vigilant. I praise You, Father, for always speaking truth to me. I know that I can trust Your words without a doubt. Amen.

"For there is no truth in [the devil].
When he lies, he speaks his native language,
for he is a liar and the father of lies."
JOHN 8:44 NIV

Greater Purpose

God, I have been drifting through my days on a steady diet of anxiety—trying to keep up appearances, keep up with the Joneses, and. . .well, just keeping up. But my life has been infused with new purpose now. I no longer wander this world wondering what it's all about and searching for the point of living.

You've commissioned me into Your army and given me an assignment to fulfill. My mission is to make disciples for You—to share the fantastic news of what living a life with You is really like. . .and to live a life that glorifies Your kingdom. I pray that You would keep me from distraction and shield me from the enemy's attacks so I can work faithfully in Your harvest. Amen.

How, then, can they call on the one they have not believed in? And how can they believe in the one of whom they have not heard? And how can they hear without someone preaching to them? And how can anyone preach unless they are sent? As it is written: "How beautiful are the feet of those who bring good news!"
ROMANS 10:14–15 NIV

More Patience, Please

Lord, sometimes when I want something to happen—when I want You to move on my behalf or change someone else's heart—I find myself tapping my foot, checking the time, and wondering what is taking You so long to make some progress.

But, Father, when it comes to my own shortcomings, I'm so very grateful for Your great and measured patience. Your love is so boundless for me that it expresses itself in unhurried patience for my spiritual growth. You don't shove me forward or stomp Your foot at my hardheaded mistakes. Instead You speak in soft whispers and diligently prune me as I grow. Father, increase my patience for other people. My stress will surely decrease as I offer more patience and understanding to the people around me. Amen.

The Lord is not slow in keeping his promise,
as some understand slowness. Instead he is
patient with you, not wanting anyone to perish,
but everyone to come to repentance.
2 PETER 3:9 NIV

The King of All

Lord, I think we all sometimes indulge in the fantasy of being queen for a day. The perks sound appealing. Who wouldn't be enamored with an unlimited budget, people to see to my every need, and all the coffee and chocolate I could want resting at my fingertips?

But as I imagine being in charge of everything, making weighty decisions, and bearing the burden of all that control, I can feel my stress levels rising. Father, I'm so thankful that I can relinquish that job to You. You are the sovereign over Your kingdom. You wield all the greatness and power of Your position. And because I trust in the King who rules everything, I can lay all the responsibility for that authority on Your capable shoulders. Amen.

Yours, LORD, is the greatness and the power
and the glory and the majesty and the splendor,
for everything in heaven and earth is yours. Yours,
LORD, is the kingdom; you are exalted as head over all.
1 CHRONICLES 29:11 NIV

Receive Mercy

Heavenly Father, Your limitless mercy is a healing balm to my soul. It soothes my aching fears and kindles hope within me that I haven't strayed too far—that I haven't crossed a point of no return where Your mercy and grace don't reach.

Lord, Your Word says that You desire mercy over sacrifice, life over death. Lead me in the way of mercy, Father, so that in everyday living I can extend Your mercy to others. May I be a beacon of light heralding Your grace and mercy to the world. It's so easy to desire retribution when I am wronged, but I must remember how my sins have drowned in the tides of Your mercy. In the name of Jesus my Savior, amen.

Let us then approach God's throne of grace with confidence, so that we may receive mercy and find grace to help us in our time of need.
HEBREWS 4:16 NIV

Learn to Be Flexible

Father, as I age my body is not nearly as flexible as it used to be. But I fear that my attitude also gets less flexible too. I'm more set in my ways, less understanding of people whose circumstances don't match up with mine, and so impatient when I don't get my way.

But, Father, I know that a flexible attitude can de-stress my life. Increase my willingness to change my plans whenever it is important—and putting the needs and desires of others first is so important! Teach me to be gracious and accepting of interruptions in my life, Lord, and less rigid with the plans I set in my mind so that I don't miss opportunities You put in front of me. Amen.

A servant of the Lord must not quarrel but must be kind to everyone, be able to teach, and be patient with difficult people.
2 TIMOTHY 2:24 NLT

Not Alone

Father, I don't like being distant from my family, friends, and job because of sickness. I'm not wired this way; I need social interaction. I need to be close to others. I need hand shaking and hugging; and unfortunately, spending time with others is frowned upon and unwise when we have certain illnesses. Help me to remember that I'm not isolated from You. Father, forgive me for social distancing from You. I've waited until things were looking desperate to call on You. But You long for a relationship with me. Help me to remember all the promises You've already kept, the battles You've already won on my behalf. You have definitely proven Yourself trustworthy. I know that ultimately Jesus wins. All the time. Every time. Even this time. No matter what. Amen.

Where can I go from your Spirit? Where can I
flee from your presence? If I go up to the heavens,
you are there; if I make my bed in the depths,
you are there. If I rise on the wings of the dawn,
if I settle on the far side of the sea, even there your
hand will guide me, your right hand will hold me fast.
Psalm 139:7–10 niv

Faith Walk

Lord, the world says that faith is blind. But I know my eyes can deceive me by what I'm unable to see. My faith eyes recognize that this world is not all there is to life. My trust in the things I'm hoping for—those wonderful things I know are waiting for me in eternity, but I can't yet see in the here and now—keeps me going through the hard times and gives my faith something to grab on to in my most difficult seasons.

God, my long, intimate journey with You has given me all the evidence I need that You are trustworthy. God, keep my eyes of faith open wide. I want to confidently follow You, knowing every word You have spoken is concrete truth. Amen.

So we are always confident and know that while we are at home in the body we are away from the Lord. For we walk by faith, not by sight. In fact, we are confident, and we would prefer to be away from the body and at home with the Lord. Therefore, whether we are at home or away, we make it our aim to be pleasing to him.
2 Corinthians 5:6–9 csb

No Shadow of Shame

Jesus, I've done things that I'm not proud of. Shame stains my life, and crimson blooms on my cheeks. My sins condemn me like the angry religious leaders who threatened to stone a woman caught in adultery. They hurled accusations like rocks and condemned her to a horrible and pain-filled death. And my sentence was the same.

But I have hope because You didn't condemn her, Jesus. Instead, You stepped into the circle of their accusations with her, and You forgave her. Just as You have forgiven me. Thank You, Jesus, that You've wiped away my shame and replaced it with the joy of knowing Your grace and mercy. I am clean! To the question, "Have you no shame?" I can shout, "No!" In the precious name of Jesus, amen.

Those who look to him for help will be radiant with joy;
no shadow of shame will darken their faces.
PSALM 34:5 NLT

One Step at a Time

God, I'm overwhelmed by this gargantuan task I'm faced with. When I look at it in its entirety, I feel defeated at the onset. It's like trying to run a marathon after training for one week while downing chocolate cake every day. I'm not sure I can see a way to get it done, and that stresses me out.

Help me to lean on You, Father—on Your wisdom and Your strength—for the job I have to finish. Show me how to put one foot in front of the other. Teach me to break it down into smaller, more manageable goals. And then give me energy and focus to start working on those goals. I know that if I can think of things in smaller chunks, I can make progress. Amen.

All hard work brings a profit,
but mere talk leads only to poverty.
PROVERBS 14:23 NIV

Simplify

Father God, I'm so overwhelmed. I've lost count of the number of times I've wished to clone myself. Not because I want a copy of myself scurrying around, but because I need help. I'm not sure I can straighten out all the details and finish all the to-do lists that clutter my plate. But maybe my harried attitude is a warning sign.

You said that You bring peace. So maybe Your expectations for my time aren't as high as the ones I've made for myself. Maybe You're asking me to be still for a while. Father, please help me to simplify my life. Show me what matters to You. And fill me with the supernatural help of the Holy Spirit to accomplish those things that are on Your list. Amen.

Make it your ambition to lead a quiet life:
You should mind your own business and
work with your hands, just as we told you.
1 Thessalonians 4:11 niv

Taste His Goodness

Father, I believe that You are good, even in the midst of this stressful season. Thank You for inviting me to taste just how good You are. Just as I roll a new food around in my mouth to investigate all of its intricate flavors, You bid me to experience every facet of Your personality and discover the sweet, delicate flavor of Your excellent goodness.

When I look for Your good workings around me, my perspective alters. I see You changing lives, bringing peace, healing hurts. Even though tragic and terrible things are happening in this world, I know that Your far-reaching gaze sees both the beginning and the end and that Your true flavor is one of complexity and layers. Serve another portion of Your exquisite goodness to this world today. Amen.

Taste and see that the LORD is good;
blessed is the one who takes refuge in him.
PSALM 34:8 NIV

Supernatural Solutions

God, I live in breathless awe of You. When the stresses of this life creep over me, I only need to remember that You are no mere man. I cannot measure You in human standards, and the vast depth of this universe cannot contain You. . .and yet You choose to live among us. You choose to take up residence in me. You spoke, and a universe exploded into being. I can't think of a more concentrated power.

When I feel alone, I need only to remember that You live with me. The limitations I see around me have no restraining power over You. When I feel despair because I can't see a way through the tough times, remind me that You are the Mighty One in possession of supernatural power. Amen.

I am God and not a mere mortal.
I am the Holy One living among you.
HOSEA 11:9 NLT

Pursue Holiness

Father God, I want to be Your obedient child. But sometimes I struggle. I slip and fall—I sin. I know that my sins only bring me stress and pain because I'm not doing the things You say are right. Instead I'm going my own way and choosing wrong. Or I'm refusing to break the habits of sin that I've fallen into.

Father, help me to practice being holy. Help me to go back and give myself a "do-over" when I mess up. Sometimes doing the right thing takes practice. And, Father, help me to love lavishly. Scripture tells me that You are love. So I know that unless I am loving lavishly, I am not being holy. Show me how I can pursue holiness this week. Amen.

*As obedient children, do not conform to the evil desires
you had when you lived in ignorance. But just as
he who called you is holy, so be holy in all you do;
for it is written: "Be holy, because I am holy."*
1 PETER 1:14–16 NIV

Seeing Clearly

Lord, when I take off my glasses, I'm pretty much blind. The world is a smear of colors with a disturbing lack of details. I fear I'm looking at life in this same manner right now. I've lost my perspective. My faith feels blurry and unsteady, my focus not quite right.

When something bad happens or things don't go my way, I've been letting it ruin my day—and sometimes my week. One negative comment from a friend, one difficult attitude from a child. . .are like ice water sheeting down my spine, bringing out the worst in me. But I know that I can bring things back into focus by putting back on my spiritual glasses and seeing things through the lens of Your Word. Help me see more clearly today. Amen.

"Then you will know the truth,
and the truth will set you free."
JOHN 8:32 NIV

After You

Father, I can't seem to get out of my own head today. I'm grumpy and stressed and maybe just a teeny bit negative and irritable. . .okay, maybe I'm more like a grizzly who woke up from her long winter nap to a stomach growling louder than she was. You already know the state of my surly mind.

Help me to get off the topic of me and focus outwardly on others. How can I outdo someone's kindness and consideration to me? How can I show a "you first" attitude? Holy Spirit, nudge me in the direction of honoring others above myself. I know that my attitude will turn around fast when I'm no longer laser-focused on me. Amen.

Love one another deeply as brothers and sisters.
Take the lead in honoring one another.
ROMANS 12:10 CSB

The Right Pursuits

God, I love rewards, achievements, and winning—even if there's no prize, I still own the bragging rights. But I have learned through Your Word that my efforts are wasted if I'm striving toward the wrong goals, if I win my prize only to discover that its profits are empty and meaningless in the lens of my eternity. I know the rewards I earn working in Your kingdom won't disappoint me, God, because they offer everlasting returns.

Help me to keep my eyes fixed on Your kingdom, Jesus. This world offers much, but it cannot give me eternity, nor does it deal in the currency of peace and hope. May I run my race well and win the ultimate prize—eternal life in Your great kingdom. . .with You. In the name of Jesus, amen.

Each one's work will become obvious. For the day will disclose it, because it will be revealed by fire; the fire will test the quality of each one's work. If anyone's work that he has built survives, he will receive a reward.

1 Corinthians 3:13–14 csb

Wait for Him

Lord, I'm experiencing both expectancy and doubt. I have become weary waiting for relief and wondering if this place of distress is where I will remain. Forgive me, Lord, for my faint heart when I become impatient waiting for You. I know You are here and You hear my pleas, but my flesh is weak.

Father, strengthen me with patience and a joyful heart in the face of adversity so I may give witness of You. Give me strength and courage each day as I need it. My peace is in You as the Holy Spirit walks before me each day, leading the way. And as the watchman is sure of the sunrise, I too am sure that You hear my cries. All things are for Your glory and my good. Amen.

I pray to GOD—my life a prayer—and wait for what he'll say and do. My life's on the line before God, my Lord, waiting and watching till morning.
PSALM 130:5–6 MSG

Becoming Righteous

Lord, it's tempting to believe that how I introduce myself to others is what defines me. And if I allow my family, my occupation, or my hobbies to define who I am, they can become the sole factor that people remember about me.

But I know that I have an even more important identity—Your daughter. Because of Jesus' blood, You don't see a sin-stained human when You look at me. Instead, I'm garbed in righteousness. Not because everything I've ever done has been righteous, but because Jesus lived my perfect walk for me. And, Father, because my heart is overflowing from all the good You've poured into my life, I want to go and sin no more too. Help me to live right today. Amen.

God made him who had no sin to be sin for us, so that in him we might become the righteousness of God.
2 Corinthians 5:21 niv

Trusting Him Alone

Lord, I'm struggling to see Your plans through my pain. Hurtful circumstances have befallen me. It would be so easy to be angry with You, to cry out and ask why. And I know You are big enough to handle my questions, my inability to understand. You are sovereign and good.

I choose to walk in faith that You haven't abandoned me here in this pain. Through my tears, I trust You. I can see that by removing false supports You also give me the precious gift of learning to trust solely in You. You give me comfort in my devastation, healing through my pain. Even if You choose not to deliver me from these circumstances and I lose something dear to me, still I choose to put my faith in You.

If GOD hadn't been there for me, I never would have made it. The minute I said, "I'm slipping, I'm falling," your love, GOD, took hold and held me fast. When I was upset and beside myself, you calmed me.
PSALM 94:18–19 MSG

My Supplier

Heavenly Father, please forgive me for prayers that make You sound like a genie in a bottle: "God, today I need. . . I want. . . " Your promise to supply my every need does not mean that I will receive every desire that flits through my discontented mind. Show me where my selfishness has exceeded my generosity.

The Philippian church had been giving sacrificially to support Paul. Have I ever gone without because I gave away something that I wanted or needed? How much stress have I heaped upon myself by trying to get more than I give? Help me to conquer my selfishness and give as generously to others as You have given to me—because You have given more than financial assistance; You have met the needs of my eternal soul. Amen.

And this same God who takes care of me
will supply all your needs from his glorious riches,
which have been given to us in Christ Jesus. Now
all glory to God our Father forever and ever! Amen.
PHILIPPIANS 4:19–20 NLT

His Best for You

Father, the morning sun unfurls warm fingers across the meadow, coaxing a crowd of decked-out wildflowers to raise their chins and smile into another day. No one plants them and no one waters and nourishes them except You, Father. Their beauty splashes across the summer landscape with unhindered artistic abandon.

You could have given small attention to their creative brushstrokes because, after all, their life is barely a blink; but that's not Your style. Every one is a masterpiece that sings of your attentive care for every detail. You are the God of the universe who is also the God of each tiny, fleeting flower. Thank You for taking the same care with every detail of my life. Amen.

If God gives such attention to the appearance of wildflowers—most of which are never even seen— don't you think he'll attend to you, take pride in you, do his best for you? What I'm trying to do here is to get you to relax, to not be so preoccupied with getting, so you can respond to God's giving. People who don't know God and the way he works fuss over these things, but you know both God and how he works. Steep your life in God-reality, God-initiative, God-provisions. Don't worry about missing out. You'll find all your everyday human concerns will be met.
MATTHEW 6:30–33 MSG

Dwell in His Shelter

Lord, You are the Mighty God, the commander of a host of heavenly armies. You are my rock in a world filled with quicksand, my shelter in the storms that I know will shake my defenses, my protector from evil, my provision in the desert. Your peace guards my heart and mind like a midnight watcher on a castle wall, ever vigilant and never sleeping. Your protection comforts my soul.

Keep me safe from evil and physical harm as I navigate this often-treacherous world. God, You are so immense and powerful, I find my rest in the peace of Your shadow. Thank You, Jesus, for the promise that You will never leave me or forsake me. I am not alone. In the powerful name of Jesus, amen.

Whoever dwells in the shelter of the Most High will rest in the shadow of the Almighty. I will say of the Lord, "He is my refuge and my fortress, my God, in whom I trust."
Psalm 91:1–2 niv

He Loves Me

Father, on my worst days, and even some of my good ones, my human mind struggles to grasp the reality that the almighty, living God of the universe, the master Creator, delights in knowing me.

But then I see my own child, for whom I feel overwhelming love—even when she's knee-deep in an emotional, dramatic hot mess. In spite of their flaws and bad days, I can't get enough of my kids. I want to understand every facet of their personalities, share life experiences with them, and shower affection all over those adorable, frustrating, loving, needy little persons. And my heart is comforted in knowing that You feel that way for me. No matter what. Thank You, Father, for lavishing Your love on me. Amen.

They are filled from the abundance of your house. You let them drink from your refreshing stream. For the wellspring of life is with you. By means of your light we see light. Spread your faithful love over those who know you, and your righteousness over the upright in heart.
PSALM 36:8–10 CSB

Live the Hope

Lord God, I want to know You with all that I am, my whole being and not just my head. Please open the eyes of my heart and send Your Spirit of wisdom and revelation so I may gain more knowledge of You.

Lord, You didn't call me into a downtrodden, stressed-out existence. You called me into a life animated with hope. Reveal Yourself to me in new ways today. Show me how You are working in my pain and struggles just as much as You are in my joy. Show me how You've showered me with Your love always, regardless of the happenings. Your great power is behind me even when I'm feeling low. Remind me of the inheritance You've promised me. In the name of Jesus, amen.

I keep asking that the God of our Lord Jesus Christ,
the glorious Father, may give you the Spirit of wisdom
and revelation, so that you may know him better. I pray
that the eyes of your heart may be enlightened in order
that you may know the hope to which he has called you,
the riches of his glorious inheritance in his holy people,
and his incomparably great power for us who believe.
EPHESIANS 1:17–19 NIV

Wear the Love Logo

Father, I'm afraid that "stressed-out mess" has become the logo of my life. Not exactly the image I want to be associated with. And even worse, my stress has been in the driver's seat for too long. I've been responding to others with whatever anxiety-driven words and actions come out first.

Father, I know that the identifying marker of my Christianity is supposed to be love. Lord, because of my love for You, teach me to be humble and gentle. Because of my love for You, expand my patience. Because of my love for You, strengthen me to bear with the struggles of others. I can love because of Your unsurpassed love for me. May I show everyone today *whose* I am—because of my love. In Jesus' name, amen.

Be completely humble and gentle;
be patient, bearing with one another in love.
EPHESIANS 4:2 NIV

Gracious Conversation

Lord, I know that the world is watching my every word and deed because they know that I belong to You. I only get a single chance on the world's stage, and it's my line. Help me to season my words with salt even when I'm feeling weighed down with worry or stress. Help me to treat every moment as something precious, an opportunity to influence the lives and eternal destinations of the people around me.

Your grace is magnetic, Father. Help me to speak both grace and truth so others will be attracted to Your abundant banquet. Help me not to cut others down, criticize, or judge. Help me to be kind and gentle in everything I say today. Amen.

Be wise in the way you act toward outsiders; make the most of every opportunity. Let your conversation be always full of grace, seasoned with salt, so that you may know how to answer everyone.
COLOSSIANS 4:5–6 NIV

Replenish My Strength

Heavenly Father, by evening I'm ready to collapse. I'm physically, mentally, and spiritually exhausted by family, work, and anxiety. But I find comfort and encouragement in knowing that I can renew my strength from Your fountain that flows eternally. Your strength never dries up. You replenish my flagging reserves.

My daily struggle works hard to distract me from the promises I read in Your Word. Help me to see how You fulfill Your promises even in the mundane details of my day. You give me strength to wash another sink full of dishes, just as You washed my sins away. You give me patience to settle one more sibling squabble or speak kindly to one more trying coworker, just as You are patient with my missteps. You are faithful. Amen.

Thank you for your love, thank you for your faithfulness; Most holy is your name, most holy is your Word. The moment I called out, you stepped in; you made my life large with strength.
PSALM 138:2–3 MSG

The First and the Last

Father, A. W. Tozer wrote a great reminder for times when things seem to be flying apart at their raggedy seams: "While it looks like things are out of control, behind the scenes there is a God who hasn't surrendered His authority."

Today, as circumstances that are beyond my control are spiraling toward chaos, I choose to meditate on the truth that You will never abdicate Your throne. My fear flees in the comfort of Your reassurances that You are the First and the Last. I may not fully understand Your behind-the-scenes movements, but I do put my total faith, love, trust, and hope in You. You will never disappoint. You will never let me down. You will knit me together when nothing else can. You are eternal, supreme, and sovereign. Amen.

He placed his right hand on me and said:
"Do not be afraid. I am the First and the Last."
Revelation 1:17 niv

Redeem My Pain

Father, You see my deep wounds. They're not easy hurts to acknowledge. And bitterness has twined its roots into my soul. It's much easier to hide my pain than to bring it into the light. But I know, Jesus, that You are gentle. And I know that healing happens in the pristine light of Your grace.

Jesus, You were laughed at, spat upon, betrayed, and denied. And then You were beaten and pierced. Yes, You understand my tear-streaked prayers and hurting places. But brokenness wasn't the end of Your story. And it's not the final ending to my story either. I trust You not to waste the pain I've endured. Instead, redeem my suffering, uphold me in the hard days, and transform me through my trials to be more like You. Amen.

We are hard pressed on every side, but not crushed; perplexed, but not in despair; persecuted, but not abandoned; struck down, but not destroyed.
2 Corinthians 4:8–9 niv

His Powerful Peace

Lord, I'm despairing. Anxiety has hijacked my thoughts, and I'm shaken by worry. My mind has been so focused on my fears that I've begun to feel alone. Satan would convince me that I'm abandoned, capable only of cowering. But I know the antidote for this kind of psychological warfare.

I may have listened to his lies for a short time, but now I'm fighting back. I'm going to give thanks and bring everything to You in prayer. I know, because Your Word tells me that this process will unleash Your sentinel of peace that will protect my heart from fear like a fierce warrior guards his city walls. Jesus, I will start right now by thanking You for being there for me always. Amen.

Don't worry about anything; instead, pray about everything. Tell God what you need, and thank him for all he has done. Then you will experience God's peace, which exceeds anything we can understand. His peace will guard your hearts and minds as you live in Christ Jesus.

PHILIPPIANS 4:6–7 NLT

Stick to the Narrow Way

Father, I know that sin is like a terminal cancer spreading quickly through my body. Ignoring it is not going to make it go away any more than ignoring sickness will heal it. The silent disease of sin will still kill me. Help me to acknowledge it, confess it, and turn away from it.

Just as tiredness or pain can be red flags of lurking disease, please make me aware of the warning signs of sin—anger, selfishness, pride, and discontent. Reveal the rotten parts of me in need of healing. Spark in me the desire to confront these wrongs and live righteously. Forgive me for sinning against You. Teach me to reject the temptation to sin. Instruct me in the ways of right living. Amen.

Point out anything in me that offends you,
and lead me along the path of everlasting life.
PSALM 139:24 NLT

Pray, Pray, Pray

Heavenly Father, Your Word says to pray always about everything. And I want to, but sometimes I forget; and other times, I just don't take the time. I rush around in my busy life and try to take care of everything myself.

Forgive me, Father, for neglecting to have a conversation with You as I make important decisions about my future. You created me and this world and set Your plans in motion; and here I am, trying to bend my circumstances to my will without even consulting You—the Master Designer. Lord, I want to talk to You more. I *need* to talk to You more, because I need Your direction and wisdom to navigate this confusing and scary world. In the name of Jesus, amen.

"Call to me and I will answer you and tell you great and unsearchable things you do not know."
JEREMIAH 33:3 NIV

I'm Awake!

Father God, before I knew You I was dead. Oh, I had a life that I walked around aimlessly in, drifting with selfish ambition as my only guide. My desires were my slave master, and I was hopelessly blind to Your purpose for my life. Depression and stress ruled my emotions.

But You found me, Jesus. You showed me an oh-so-much-better way, and I felt You breathe living breath into this husk of a human. And now I am alive! I have awakened to Your good plans for me. It's as if a blindfold has fallen from my eyes, and suddenly I see You everywhere. I see You in the pattern of each unique snowflake, I hear Your joy in a child's belly laugh, and I feel Your comfort in my pain. I have found new meaning in living for You. Amen.

"Awake, O sleeper, rise up from the dead,
and Christ will give you light."
EPHESIANS 5:14 NLT

Living for Him

God, I thought I was hopelessly stuck—that I could never be any different than I am. I didn't think that my small life was worth much to anyone, much less the God of this universe. And the people around me seemed to confirm this; no one saw a glimmer of potential in me.

But, Father, You did. You reached out with a nail-scarred hand and took ahold of mine. You told me that I was precious. You changed me into something new. Praise You, Jesus! The stressed-out, hopeless me is no more. I'm thinking differently than I used to. I'm doing things differently than I used to. I'm living instead of merely existing. And instead of living for myself, I'm living for You! Thank You, Jesus. Amen.

And he died for all, that those who live should no longer live for themselves but for him who died for them and was raised again. So from now on we regard no one from a worldly point of view. Though we once regarded Christ in this way, we do so no longer. Therefore, if anyone is in Christ, the new creation has come: The old has gone, the new is here!
2 CORINTHIANS 5:15–17 NIV

Setting Things Right

God, it's not supposed to be like this! Children aren't supposed to suffer from neglect and abuse; families aren't supposed to break apart in divorce; hatred and greed aren't supposed to cause wars. Sickness, fear, selfishness. . .evil—it saturates this world. It can be so hard to believe in the face of such sadness.

But You, Lord, see the end. You know that the wicked ones in this world will not prosper forever. You know that You are preparing a perfect place, a kingdom as it was meant to be before our sin devastated Eden. And this time our sins are covered by the blood of Jesus. In the midst of this temporary trouble, I know You will make everything right. . .soon. Amen.

Surely God is good to Israel, to those who are pure in heart. But as for me, my feet had almost slipped; I had nearly lost my foothold. For I envied the arrogant when I saw the prosperity of the wicked. . . . When I tried to understand all this, it troubled me deeply till I entered the sanctuary of God; then I understood their final destiny.
PSALM 73:1–3, 16–17 NIV

Don't Fall for Pride

God, my pride is so deceptive and sly. My thoughts wander, and suddenly I notice some aspect of my life that seems just a little bit better. Why does my mind seem to bend naturally toward comparison and love to find areas where I excel so I can feel good about myself?

But I know that Your kingdom is different, Jesus. Help me to see when I'm all puffed up with pride. Because with You, the least is the greatest and the first is last. You reward the humble and oppose the proud. Jesus, I am unworthy of Your love; I stumble into sin far too often, but You saved me anyway. Keep me vigilant in curbing my pride so I may walk in humility and kindness. Amen.

When pride comes, then comes disgrace,
but with humility comes wisdom.
PROVERBS 11:2 NIV

Daily Scrub

Heavenly Father, sometimes daily tasks pile up and my attitude about doing them is as dull as the shine on my fingerprint-smudged refrigerator. Washing dishes is one of those tasks. But as I scour another crusty pan, help me remember that I used to be a grimy rag in need of a stiff scrub too.

Father, I know that I now belong to You. And You've washed away the scandalous smears of my shame. I'm walking around in Your righteousness. And wow, it feels good. But I'm not perfect, and I keep staining myself with pride, anger, selfishness, and impatience. I hurt people, and I make messes. I still need Your Holy Spirit to swirl the murky waters of my conscience and show me the dirt I've missed. Amen.

Pure and undefiled religion before God the Father is this: to look after orphans and widows in their distress and to keep oneself unstained from the world.
JAMES 1:27 CSB

Safety Net

God, I'm losing ground. Whether it's temptations that hound me, financial strains threatening my security, tense relationships that wring me out emotionally, or a dire medical diagnosis—my feet are slipping out from under me. I choose to turn to You, sovereign Architect of eternity, for help in my upheaval.

Support me with Your forever faithful love. Lead me into a restful place of peace even in the middle of such stress-inducing circumstances. Teach me to discover the joy that comes from resting in the calm assurance of Your comfort. The ups and downs of every tumultuous day can't rob me of the joy of living each moment in Your good and holy presence. Catch me when I slip, and plant my feet on the solid ground of my belief in You. Amen.

If I say, "My foot is slipping," your faithful love will support me, LORD. When I am filled with cares, your comfort brings me joy.
PSALM 94:18–19 CSB

Hungry for More

God, I don't understand even a fraction of what there is to know about You. And sometimes I feel the worries and stress mounting again as my mind seeks to make sense of a world that appears tossed about by the decisions of powerful people, sicknesses, and money.

I'm so grateful that You've sent me the Counselor to teach me more about You. I'm amazed that every time I believe I've grasped all that You want me to know, You astonish me with Your limitlessness. Thank You for patiently instructing me, building on the things I've learned about Your love and grace. Please teach me more. I'm fascinated by Your complexity and precision. The more I discover of Your greatness, the more I entrust myself to Your care. Amen.

But the Counselor, the Holy Spirit, whom the Father
will send in my name, will teach you all things and
remind you of everything I have told you.
JOHN 14:26 CSB

Hold on to Him

Lord, I'm not sure I can handle this day. . .or the one that comes after it. I want to hide from the struggle I'm facing. I long for a break, for You to pause time like You did for the Israelites so I can rally my forces and win the battle as Joshua did. I feel so depleted.

And because my resources are tapped out—physical, mental, emotional, and financial—stress gnaws at the scraps of my reserves, depleting me even further. I'm holding on by a single, fraying thread. But I know that You will sustain me as long as my last thread of hope is the hem of Your garment. Hold me up as Moses' friends supported him during battle. In Jesus' name, amen.

When Moses' hands grew tired, they took a stone and put it under him and he sat on it. Aaron and Hur held his hands up—one on one side, one on the other—so that his hands remained steady till sunset. So Joshua overcame the Amalekite army with the sword. Then the LORD said to Moses, "Write this on a scroll as something to be remembered."
EXODUS 17:12–14 NIV

He Fills My Every Need

God, I'm struggling with discontent. More stuff, more time, more money—what I have never seems to be enough. If I'm not paying attention, before I know it I'm obsessed with *more*. I tell myself, *If I just make a few dollars more, get a nicer car, have an improved house, then I'll be happy.* But this beast of desire is never satisfied. Instead, when I indulge my appetites I'm left feeling emptier than ever. . .and I want even more.

Father, instead of these insatiable desires, fill me with the desire to pursue holiness, to live fully within Your will. You offer me contentment and rest—a rest from the need to obtain more. I'm so glad that You're all I'll ever need. Amen.

The LORD is my shepherd; I have all that I need.
He lets me rest in green meadows; he leads me
beside peaceful streams. He renews my strength.
He guides me along right paths, bringing honor to his
name. Even when I walk through the darkest valley,
I will not be afraid, for you are close beside me.
Your rod and your staff protect and comfort me.
PSALM 23:1–4 NLT

Salt and Light

Father, You tell me to love others as much as I love myself. But to love them, I need to first have a relationship with them. I live in a world of texting and video conferencing. I'm not even sure of some of my neighbors' names. Show me how I can make personal connections with others so I can be salt and light for You, Jesus. Let my behavior and words show love, respect, kindness, and gentleness toward them no matter what situations I find. Help me love them even if we disagree on our religious, political, and lifestyle choices. No matter who You bring into my circle, help me love them, like You love me. In the name of Jesus, amen.

*" 'Love your neighbor as yourself.' There is
no commandment greater than these."*
MARK 12:31 NIV

Reconciled

Father God, scripture tells me it's Your great desire that I live in peace with You and also with those around me, especially my fellow believers in Christ. I know my sins create a rift between You and me. Compared to Your brilliant and perfect glory, my heart is tattered and stained by my wrongdoings. But through Your mercy, You wash away my grime so I become as white as newly fallen snow.

Thank You, Jesus, that because of You I am reconciled with my God. Lord, soften my heart and bring reconciliation and forgiveness to my relationships as well. Show me any relationship that has become strained by something I've done or an offense I've been unwilling to forgive. In the name of Jesus, amen.

"Come now, let us settle the matter," says the LORD. "Though your sins are like scarlet, they shall be as white as snow; though they are red as crimson, they shall be like wool."
ISAIAH 1:18 NIV

God's Recipe

Father, when I'm baking my favorite chocolate cake, I melt butter and crack a few eggs. Dump in some flour, salt, sugar, and baking soda. The mess in my bowl doesn't look very appetizing; but I know from experience that as long as I follow the recipe and stir it all together and pop it in the oven for a bit, I'll end up with the yummiest, most sigh-worthy chocolate cake I've ever tasted.

Help me to remember this in life. The stuff in my bowl of life might not look that palatable—I might have some loss and sadness, anger, pain, or failure— but I know from my past experiences of walking with You, Jesus, that You have a good plan for me as long as I walk with You. Thank You, Jesus. Amen.

And we know that God causes everything to work together for the good of those who love God and are called according to his purpose for them.
Romans 8:28 nlt

Secure in You

Heavenly Father, when I honor and respect You with my life, You promise that You will be my secure fortress. Stress and fears assault me. They dig in to lay siege against me. Let me fear no one but You. Let Your love for me and sovereign authority be the comfort that I need in this world.

Just as my children run to my arms for safety, I will run to Your arms for protection. Help me to teach my children that while I bring them comfort, it is You who brings us ultimate comfort and protection. Let my faith in You become a shelter for my children in this cruel and dangerous world, as they learn to follow You. Amen.

Whoever fears the LORD has a secure fortress,
and for their children it will be a refuge.
PROVERBS 14:26 NIV

I'm Covered

Father, thank You for sending Your one and only Son to die for my sins. You are truly an amazing and loving God that You would suffer pain and give so much on my behalf. I know my actions and words have not always brought You joy, and I don't always put You first.

Despite all that, I am thankful that I can fall on my knees and ask You to forgive me. . .and You don't hold my sins against me. I can't imagine the pain and sadness You experience when I am disobedient. But great joy rushes into my heart with the realization that I have been blessed beyond compare because You have forgiven me. You've got me covered! In the name of Jesus, amen.

"Blessed are those whose transgressions are forgiven, whose sins are covered."
Romans 4:7 niv

Unfaltering Focus on Jesus

Lord, distractions abound in this world. If Satan cannot turn me from following You, he is at least content to distract me from actively pursuing Your cause.

Keep my focus on You, Jesus, because when my eyes stray to other things, I, like Peter, falter, and fear swoops in on dark wings. This world entices with temporary comforts, but You offer eternal rewards and true life that will never end. Plant me firmly in the foundation of Your Word so the enemy's lies will not sway me. Give me steadfast devotion to You, Jesus, so I run my race well and win the crown. I long to feel Your welcoming embrace and hear You say, "Well done, My faithful daughter." Amen.

Blessed is the one who perseveres
under trial because, having stood the test,
that person will receive the crown of life that
the Lord has promised to those who love him.
JAMES 1:12 NIV

Sing a New Song

Lord, thank You for giving us the gift of music and favoring many with the ability to create it. It lifts my flagging spirits to make a joyful noise to You.

Just like setting my radio to praise music, Lord, set my heart to worship You today. Remind me—when I'm struggling to make it through the day—to sing praises to You. After a few songs, I notice my attitude and heart easing into rest as I shift my focus back onto You. It's hard to stay in a bad mood when I'm singing of Your unending love, amazing grace, and generous mercy. Lord, I love You, and I lift my voice to offer the sweet sounds of worship to You. In the name of Jesus, amen.

Worship the LORD with gladness;
come before him with joyful songs.
PSALM 100:2 NIV

Taming of the Tongue

Father God, sometimes the smallest things can cause total devastation. Like a spark igniting a forest fire, my tongue can scorch others too. When my anger gets the best of me, my tongue spews damaging words in every direction. If my self-control slips, destructive words fly out and tear down my coworkers, friends, and family.

Lord, help tame my tongue from gossiping, lying, false teaching, and putting others down. Grant me wisdom to stop and think about the potentially dangerous consequences of the words about to leap from my lips. If my words are not useful for building someone up and encouraging, help me keep my comments to myself. Help me to use this standard more often: Is what I want to say true? Is it necessary? Is it kind? Amen.

Though the tongue is a small part of the body,
it boasts great things. Consider how a
small fire sets ablaze a large forest.
JAMES 3:5 CSB

Let's Celebrate!

Lord, as a parent I'm thrilled to celebrate my children's accomplishments, even if it is only the magnificent feat of growing a year older. We will still sing and laugh and eat cake, and the wrapping paper will fly.

I am so overjoyed at my kids' successes. How could I ever entertain the thought that You would not celebrate me, Your beloved daughter? Your Word says that there's more joy in heaven over one repentant sinner than over all the righteous—and that You rejoice over me with singing. You love me and experience indescribable joy when I and others are born into Your kingdom. Father, fill me with Your joy. May I spread it to others today! Amen.

Let them praise his name with dancing and
make music to him with tambourine and lyre.
For the LORD takes pleasure in his people;
he adorns the humble with salvation.
PSALM 149:3–4 CSB

Call on His Name

God, as I tread through my time on this earth, I more fully grasp the importance of Your precious forgiveness. My mess-ups and problems multiply like garbage in a dump. I'm helpless to erase them or soothe away the sting of so many mistakes. My anxiety accuses me, and I'm stressed because what's done is done—I can't get rid of my garbage on my own.

But thank You, Jesus, that I don't have to. . . because You have forgiven my sins. You cast them into a sea of forgetfulness and clothed me in pristine white robes. No other name can save me, Jesus. Only Yours—the Christ, the Son of the living God, the Lamb who died and rose again. In the saving name of Jesus I pray, amen.

If you confess with your mouth, "Jesus is Lord,"
and believe in your heart that God raised him
from the dead, you will be saved.
ROMANS 10:9 CSB

A Mother's Comfort

Father, when I hear my child's anguished cries in the night, my instinct is to cuddle with her and shush away her fears, to sing a lullaby, and to assure her that all is well. I don't leave her until her every fear has been calmed and rightness has been restored to her world.

There are times when this grown-up girl needs these same assurances too. I need Your presence to comfort me when I walk through dark valleys. I need to shelter under the shadow of Your mighty wings when I face the storms and be held close to Your side. I need to read Your words of comfort. I need to feel the soothing peace that passes all understanding flood my mind and heart. Amen.

"As a mother comforts her child, so will I comfort you; and you will be comforted over Jerusalem." When you see this, your heart will rejoice and you will flourish like grass; the hand of the LORD will be made known to his servants.
ISAIAH 66:13–14 NIV

Mending Marriage Stress

Father God, my marriage is on rocky ground. Our relationship is increasingly stressful, and I'm not sure where we took a wrong turn. We both seem to be struggling with stress and the tension of even the small things that used to flow by. We blame one another instead of examining our own actions, and we take our stress out on each other. I'm afraid we're drifting apart, Father.

Please show me how to stop the drift before we can no longer reach one another. Teach us healthy and appropriate coping mechanisms to deal with our stress instead of lashing out. Show us what we need to do to get through this stressful season together. Show us how to trust You more. Make me sensitive to Your gentle guidance. Amen.

Therefore confess your sins to each other and pray for each other so that you may be healed. The prayer of a righteous person is powerful and effective.
JAMES 5:16 NIV

Draw a Cleansing Breath

Father, please help me to step away from my problems for a while until I can calm my raging feelings and find my self-control again. Sometimes my frustration morphs me into the worst version of myself. Especially when I give in to my emotions and slam that door or yell—my inner Hulk shreds through my peace like tissue paper.

I need to take a few cleansing breaths and pour out how I feel to You instead of banging pots and pans in the kitchen. I know that You care about every facet of my life, including my frustration and my everyday problems. Please take my struggles into Your capable hands. I love You, Father, and I know You love me too. Amen.

Do not fear, for I am with you; do not be afraid, for I am your God. I will strengthen you; I will help you; I will hold on to you with my righteous right hand.
ISAIAH 41:10 CSB

Sweet Sleep

Lord, You offer priceless gifts to me—gifts I could never hope to afford with the deeds I've been doing. This world is heavy, and I've been lugging its weight as I work frantically from before dawn until after the last golden rays have spilled across the evening sky only to be swallowed by shadows. I worry and fret and work some more.

But You want me to have rest. Rest and peace for my soul—an internal oasis in the midst of this gale-force life. Jesus, teach me to abide in You, to remain and be present with You always—regardless of my circumstances. In my joy or in my pain, in stillness or in chaos, my soul rests in You. Amen.

In vain you rise early and stay up late,
toiling for food to eat—for he grants
sleep to those he loves.
PSALM 127:2 NIV

Christ Living in Me

Heavenly Father, what a mighty God You are! But there was a time that I didn't have a relationship with You. And I'm not proud of some of the things I did before I came to know You. My words and actions didn't glorify You. In my rebellion, I suffered many failures of my own making, but I'm thankful for these scars because they brought me to the realization that I needed You. What a joyful day that was when I met You, Jesus, and our relationship began.

Now I'm no longer living for myself, but for You. Let everything that I do and say shed the light of knowing You into a dark world. May it shine on my family, friends, coworkers, and anyone who meets me today. Amen.

I have been crucified with Christ and I no longer live, but Christ lives in me. The life I now live in the body, I live by faith in the Son of God, who loved me and gave himself for me.
GALATIANS 2:20 NIV

Serenity in Submission

Lord, I know that I may drag my feet into some endeavors because I'm scared or nervous about the journey or the outcome. Help me to become more like Jesus. He was willing to do Your will, even though He knew what lay ahead. His courage, total submission to Your will, and self-sacrifice are unparalleled in this world.

I may not know what is ahead in my journey, but I know both happiness and heartache live in my future. It brings me comfort and peace to know that my faith in You is enough. Let me live out Your will and not mine. Give me boldness, courage, and great love for others as I follow You. In the matchless name of Jesus, amen.

"Father, if you are willing, please take this cup of suffering away from me. Yet I want your will to be done, not mine."
LUKE 22:42 NLT

Called to Love

Jesus, too often I deal in judgment instead of mercy. I see someone stumbling or messing up and I think, *What is their problem?* I see their failure, but I miss the pain and brokenness that is causing their missteps.

Jesus, open my eyes! Help me to see others through the lens of Your love. Move me with compassion for those wandering sheep who haven't encountered their Shepherd. It may be easier and more comfortable to look away from others' painful and messy lives, but You have called Your children to love. Forgive me for my hardened heart, Father. Forgive me for turning a blind eye to the painful and debilitating circumstances that have carved hopelessness into the lives of others. Show me the stunning potential You see in them. Amen.

When Jesus landed and saw a large crowd,
he had compassion on them, because they
were like sheep without a shepherd. So he
began teaching them many things.

MARK 6:34 NIV

Fatherly Hugs

Father, when worries and cares are heavy on my heart and mind, I rest in the comfort of knowing that You already know all about them. You know completely all that will happen even before I come to You in prayer over the circumstances that are weighing on me. You are like the closest friend who is intimately familiar with everything about me—You know who I am, what I do, how I feel.

It's comforting and wonderful to know that You hem me in. Like a big, warm hug from my adoring heavenly Father, You wrap me in Yourself and rest Your hand on my life. It's just too amazing to know that this is real. I am not alone, *ever*. In the name of Jesus, amen.

You have searched me, LORD, and you know me. You know when I sit and when I rise; you perceive my thoughts from afar. You discern my going out and my lying down; you are familiar with all my ways. Before a word is on my tongue you, LORD, know it completely. You hem me in behind and before, and you lay your hand upon me. Such knowledge is too wonderful for me, too lofty for me to attain.
PSALM 139:1–6 NIV

Greater Than Gold

Lord, we all have certain loves that we sometimes obsess over. Hobbies, people we like, places we want to travel, even our jobs. Whatever it is, it can be on our minds all the time, taking up all the available real estate in our thoughts.

But, God, I know that wisdom can be a lot like these obsessive thoughts. When I pursue Your wisdom all the time, search for it in the pages of scripture every day, and think about it often, You will show me how to live according to Your will in each and every situation. Father, I want to search for Your wisdom. Fill me with the desire to pursue it. And thank You for the promise of wisdom's great rewards. Amen.

Blessed are those who find wisdom, those who gain understanding, for she is more profitable than silver and yields better returns than gold.
PROVERBS 3:13–14 NIV

The Best Medicine

Lord, I need an attitude adjustment. I know it. I'm pretty sure everyone around me knows it too. Please forgive me for dwelling on the most negative aspect of every situation, person, or mishap I encounter. I've become my own personal dark thundercloud, raining dread and spewing poisonous negativity on everyone around me.

Your Word says that an optimistic outlook is like good medicine to my soul. It's like bringing happiness to myself. And I'm sure my family and coworkers wouldn't mind a little cheer in my perspective these days either. I know that You have good things ahead for me, and You desire to give me the gift of a cheerful heart and an optimistic outlook. Help me to dwell on my blessings instead of my problems. Amen.

A cheerful heart is good medicine,
but a crushed spirit dries up the bones.
PROVERBS 17:22 NIV

Good Comfort

Father, I've been in this miserable place. I've opened myself up and shared my vulnerable worries and fears with friends only to be misunderstood. They listened for a minute and offered a quick solution that is a mere bandage on a ruptured artery. Job understood this. His friends told him how they thought he deserved what was happening to him and the pain he was going through. They judged him.

God, help me to remember this hopeless feeling of receiving miserable comfort from friends so I don't ever offer empty platitudes to suffering people. I know that You alone see what is really going on in my heart and life. Help me to be a compassionate and understanding comforter, as You are to me. Amen.

*"I have heard many things like these;
you are miserable comforters, all of you!"*
JOB 16:2 NIV

Opposition into Opportunity

Lord, times are hard. The world teeters on uncertainty, and I feel stressed and uneasy as a result. People are afraid and watchful—some take advantage of the situation, some hide.

But, Father, I want to honor Jesus in this suffering. I want to offer hope to the world around me—the hope of a bright future in eternity with You, the Father God who loves us. I want to let them know the amazing reason that I have hope—because of the resurrection of Jesus. Jesus reassured His disciples at the last supper by offering them peace in tumultuous times. Father, help me to turn opposition into the opportunity to share Your living hope. I look forward to someday being with You forever. Amen.

In all this you greatly rejoice, though now for
a little while you may have had to suffer grief in all
kinds of trials. These have come so that the proven
genuineness of your faith—of greater worth than
gold, which perishes even though refined by fire—
may result in praise, glory and honor when Jesus
Christ is revealed. . . . For you are receiving the end
result of your faith, the salvation of your souls.
1 PETER 1:6–7, 9 NIV

An Amazing Place

Lord, I can't imagine what my everlasting future with You will be like. I can't fathom the wonders I will see. The joy that will consume me in Your presence. I know that You are preparing a home for me that is beyond my wildest imagination. A place where there's no more crying, no more death, no sin—no more sadness. Jesus will be there to wipe away every tear. I know that this place will be more fantastic than any place I have ever experienced before. There won't even be a need for churches anymore because You are there. We get to reside in Your unfiltered presence forever. And this expectant thought brightens my every day with hope in this dark world. Amen.

The twelve gates were twelve pearls, each gate made of a single pearl. The great street of the city was of gold, as pure as transparent glass. I did not see a temple in the city, because the Lord God Almighty and the Lamb are its temple.
REVELATION 21:21–22 NIV

Mighty and Awesome God

God, I have been guilty of forgetting just who You are—the First and the Last, the almighty God, the God who created everything, the controller of this vast universe, the God who parted a sea, the One who froze the sun in the sky, the One who brought down a giant with a tiny rock. . .the One who rose from the dead.

My fragile human mind tries to put You in a box defined by my limited understanding of Your power, but I know You are so much greater than what I can comprehend. I know that nothing escapes Your ability. Lord, what do I have to worry about? You've got this, all of it. Every single little detail filters through Your fingers. Help me to rest in this knowledge. Amen.

"For the LORD your God is the God of gods and Lord of lords. He is the great God, the mighty and awesome God, who shows no partiality and cannot be bribed."
DEUTERONOMY 10:17 NLT

Shine on Me!

Father, we're all flooded with blessings—they're all around us. You, our great God, have blessed us with resources we sometimes don't even recognize. Whether it's the way we encourage others, the money we have, a strong back to help out an elderly neighbor, or even just our time.

Father, I give back to You every week with my tithe, but You don't want my giving to stop at dropping some money in a plate. Show me how to give of my time, my resources, my energy. Show me how I can use whatever I have to love my neighbors and help someone out. And, as I spread Your love to a hurting world around me, I feel Your peace descend on me. Amen.

"The Lord bless you and keep you; the Lord make his face shine on you and be gracious to you; the Lord turn his face toward you and give you peace."
Numbers 6:24–26 niv

Healing Prayer

Lord God, You already know of the frighteningly bleak news I received from my doctor. My stress has spiked over my health concerns. I am far from well, and I ask for Your speedy healing of my body. This news has come as a shock to my mind. Please fill my mind with Your peace. Show me what I can do to improve my health. Give me wisdom in my life choices so I can live for You longer, Lord.

I'm reeling from the terrible prognosis I've been given. Father, if it be Your will for me to work a little longer for You here in this world, please heal my body. All glory to You, great Father. Amen.

Heal me, LORD, and I will be healed; save me and I will be saved, for you are the one I praise.
JEREMIAH 17:14 NIV

Listen Well

Father God, when I'm having a bad day or going through tough circumstances it's tempting to flood every conversation with my problems, my worries, my needs. But I know that this kind of self-focused behavior will only serve to increase my stress levels and weary my friends with my constant complaints.

Please help me to shift my focus outward. Sure, I can share and ask for prayer and advice, but I want to also consider the needs of my friends. No one wants to feel as if they never have a turn in the conversation. I want to be a more loving friend who shows concern for what's happening in the lives of others. I know my stress will ease as I lend a listening ear to my friends. Amen.

No one should seek their own good,
but the good of others.
1 CORINTHIANS 10:24 NIV

Choose Him

Lord Jesus, You have challenged those of us who would be Your disciples to take up our crosses and follow You daily. You've told me that if I want to save my life, I must lose it. Well, Lord, I'm ready to lose myself to You. I haven't been doing such a great job on my own. I'm tripped up in worry and wrung out with stress.

So I choose You, Jesus. I have enslaved myself to righteousness. The world doesn't understand why I would sacrifice to serve You. Surrender can be excruciating, as Calvary was for You. The death of my pride and selfishness *is* painful. But You promise me something so much greater. In return, You have gifted me eternity—and abundant life now. Amen.

Therefore, I urge you, brothers and sisters, in view of God's mercy, to offer your bodies as a living sacrifice, holy and pleasing to God—this is your true and proper worship. Do not conform to the pattern of this world, but be transformed by the renewing of your mind. Then you will be able to test and approve what God's will is—his good, pleasing and perfect will.
ROMANS 12:1–2 NIV

Embrace Forgiveness

God, excise this bitter disease from my heart and implant Your love that covers all wrongs. I have been wounded by others, but I long to release my pain and anger to You and submit to Your physician's hand on my bruised heart. I know that trudging into the swamp of bitterness leads to my own destruction, but the path of forgiveness brings life.

This anger is eating at me and festering inside. To forgive is to let go—of my anger, my blame, my bitterness—and to grab ahold of life, freedom, and healing from You. I will no longer glory in my offenses and bitterness toward others; instead, I will glory in overlooking slights and hurts and in forgiving as You have forgiven me. In Jesus' name, amen.

Get rid of all bitterness, rage, anger, harsh words,
and slander, as well as all types of evil behavior.
Instead, be kind to each other, tenderhearted,
forgiving one another, just as God through
Christ has forgiven you.
EPHESIANS 4:31–32 NLT

Unseen Defenders

Father, I know that whatever problems I will face today, there are more with me than against me. When I'm walking in Your will, Your angel army surrounds me and defends me from any evil that would come against me. Help me to remember that even when I feel outnumbered, You are by my side. Your angels are with me.

Thank You for surrounding me and filling me with strength. Even when I can't see them and don't understand what is going on around me, when things look bleak and it appears as if the enemy is on the brink of victory over me, I have unseen defenders fighting on my side. In the powerful name of Jesus, amen.

"Don't be afraid," the prophet answered.
"Those who are with us are more
than those who are with them."
2 Kings 6:16 niv

Equal Footing

Lord, I am so thankful that You created all of us equal in Your sight. You don't play favorites with Your children. I am loved by You unconditionally, just the same as You love us all—whether we have been abused or abandoned, broken by tragic circumstances or strung out on drugs, homeless or jobless or seemingly loveless, You care for us. Living in the lap of luxury or on the street, Your love for us is the same.

Each and every one of us has been blessed with twenty-four hours a day and seven days a week; and I will praise You in each of those moments. Help me to remember when I feel inadequate, less than, or marginalized. . .You do not create mistakes. Amen.

Rich and poor have this in common:
The LORD is the Maker of them all.
PROVERBS 22:2 NIV

His Will

Father God, I'm disappointed. Something that I really wanted to happen isn't going to. It's hard to swallow the sense of sadness and loss that I feel. But I know that I'm not completely in control of what is going to happen.

Help me to be flexible and trust You even when I make plans in my heart for what I want. Help me always to hold my own plans loosely and to offer them up to You for Your input. I know that Your will is working in a way that I don't always understand, but I trust that You have my best interest at heart. You are in control, my powerful and great God. I trust You to work Your good will in my life. Amen.

Instead, you ought to say, "If it is the Lord's will, we will live and do this or that."
JAMES 4:15 NIV

His Glorious Riches

Lord, my overspending has gotten out of control. I feel powerless to get myself onto a path toward recovering financially. I don't know what to do. It seems as if the harder I try to turn things around, the more money crises I'm hit with.

Help me to depend on You instead of always trying to fix things myself. I have already proven that I need help. I know that You hold my future in Your hands. Help me to lean into this truth, to believe it in my heart—not just know it in my head. I trust You to help me get through these difficult financial times. Teach me to have real faith in You. Teach me wisdom in my financial decisions. In Jesus' name, amen.

And this same God who takes care of me will supply all your needs from his glorious riches, which have been given to us in Christ Jesus.
PHILIPPIANS 4:19 NLT

Stillness in the Storm

Lord, it seems we have but one certainty in this world: it will rain. Gale-force winds will howl, and life is going to get dicey for a while. My mind will flood with uncertainties and fears as the enemy attempts to scatter the seeds of doubt in my fertile grounds of fear. But in the midst of these turbulent waters, You are the Prince of Peace who leads me beside quiet streams.

The disciples screamed in terror when it seemed the storm would overtake them, but You, Jesus, peacefully slept. Give me that kind of unruffled rest in the middle of the storm. When the disciples woke You, You said, "Be still." Calm my mind and emotions with the stillness of Your peace—just as You settled those waves—no matter what torment rages around me. Amen.

"I have told you all this so that you may
have peace in me. Here on earth you will
have many trials and sorrows. But take heart,
because I have overcome the world."
John 16:33 NLT

Unrestrained Praise

Father, often when I hear the words "Praise the Lord," I think of singing at church or lifting my hands. But it really just means to give You credit for how amazing You are. In the Bible, the people raised up huge banners of praise for everyone to see. But I know that I don't need such fanfare to praise You. I don't have to be in church, and I don't even need to be having a good day.

In fact, praising You on the bad days is one way to remember just how incredible and faithful You are. Unrestrained praise in the trials boosts my morale. I will praise You, awesome Father, no matter what! In the matchless name of Jesus, amen.

"Praise the Lord, all you Gentiles;
let all the peoples extol him."
Romans 15:11 niv

Family Ties

Lord God, my family seems to be weighed down by such a load of stress. I pray that You would help to relieve us of this load and give us strength to bear what we must. We are all so exhausted. I love my family, and I feel lavishly blessed that You have put these special people in my life. I know that this tension and mounting pressure are not good for us. It strains our relationships and drives our emotions.

Please give me wisdom in the ways that I respond to my family in this stressful time. Help me not to react in anger or impatience. Show us how to love one another well as You love us. Teach us to release our burdens into Your humble and capable hands. Amen.

The righteous cry out, and the LORD hears them;
he delivers them from all their troubles.
PSALM 34:17 NIV

Special Possession

Lord, for some unidentifiable reason, You've chosen us—all of us measly and ungrateful sinners—to become a part of Your family. You don't have to love us, but You do. You didn't have to die for me, but You did. You called us out of darkness and into the marvelous light of Your grace.

You are the spectacular God, capable of making things that are not come into being. We were scattered, wandering like sheep with no shepherd—intent on our own deaths—and You gathered us into a holy family. We were condemned, and You pardoned us with mercy. You picked me, and all I need to do is choose You back. I choose You! In the name of Jesus, amen.

But you are a chosen people, a royal priesthood,
a holy nation, God's special possession, that you may
declare the praises of him who called you out of darkness
into his wonderful light. Once you were not a people,
but now you are the people of God; once you had not
received mercy, but now you have received mercy.
1 Peter 2:9–10 niv

Refuge

Lord God Almighty, You bolster me with new strength when I am weak. When I falter and my faith trembles with the strain of a single forward shuffle, You are there. When the pressure mounts and I'm not sure I can withstand the stress, You are there. When the enemy attacks and doubt and fear surge into my heart, You are there.

You are the all-powerful God of the universe, and You have promised that I am not on this faith journey alone. Lend me Your strength through every trying, difficult, or painful moment of this day. Give me the energy I need to do Your good work and the desire and will to choose Your way over mine. In Jesus' name, amen.

The LORD is good, a refuge in times of trouble.
He cares for those who trust in him.
NAHUM 1:7 NIV

The Good Life

Lord, I know You want me to stand out, to abstain from evil and cling to what is good. But in the past, I have followed bad examples. I have allowed myself to be influenced by what other people will think if I do what You say is right and refuse to engage in wrongdoing.

You have placed these limits on my behavior for a reason. Because my life will go much better when I don't imitate evil—whether it's falling into gossip or failing to tell the whole truth. Father, help me to imitate You, to live set apart as holy in this world—just as Jesus did. Keep me from doing as the world does, with no regard for Your ways. May I be a light to those around me. Amen.

Dear friend, don't let this bad example influence you. Follow only what is good. Remember that those who do good prove that they are God's children, and those who do evil prove that they do not know God.
3 John 11 NLT

Healing the Distance

Lord, when someone spreads rumors and mean-spirited talk behind my back, it's upsetting and stressful; but when a good friend is the culprit of the gossip, it hurts even more. When someone close to me hurts me, the pain hits a deeper level. And not only does it hurt, but I feel like I've lost something as well—the shared trust between close friends. I'm not sure our friendship will ever be the same.

Father, I know that You are grieved by my actions when I turn away from You. Forgive me for hurting the One who has given so much for me. I want closeness with You. Show me any way in me that isn't pleasing to You, and heal this distance between us. I love You. Amen.

And do not grieve the Holy Spirit of God, with whom you were sealed for the day of redemption.
EPHESIANS 4:30 NIV

Refreshed

Father, I'm feeling parched by life. I spend my time with worried thoughts and anxious feelings swirling in my gut. You know that my problems aren't trivial. This life is fraught with weighty issues, big decisions and problems that deserve thought, preparation, and prayer.

But Father, don't allow me to turn my thoughts inward and focus only on the difficult things that I have to juggle every day. This obsessing leads only to fear and stress. Father, I'm trusting You to work out the kinks in my life—and while You do, I will focus on others who are also struggling. I will reach out in love and refresh someone else. I know that, in turn, as I lavish Your love on someone, I too will be refreshed. In Jesus' name, amen.

A generous person will prosper;
whoever refreshes others will be refreshed.
PROVERBS 11:25 NIV

Childlike Abandon

Lord, You are my perfect example, and I want to follow in Your sure footsteps. I'm not perfect; it's inevitable that sin will trap me in its net, but I desire a godly life. Fill me with the good and succulent fruits of Your Holy Spirit—love, joy, peace, patience, kindness, goodness, gentleness, faithfulness, and self-control. Teach me to live a life of integrity that my children can imitate. Prevent me from becoming a stumbling block for my children, but instead mature me into a steady example in my actions and words. Give me diligence and patience as I teach my children about the amazing God we love, and who loves us, so they too can experience great blessings as they faithfully follow You. In the name of Jesus, amen.

A righteous person acts with integrity;
his children who come after him will be happy.
PROVERBS 20:7 CSB

Compassionate Patience

Jesus, patience is not a strength I have mastered. Why, when You have shown me limitless patience, am I so impatient with those around me? I want things to happen now, and I don't want to be bothered with others' problems because they might interfere with my own agenda. I have hardened my heart toward their brokenness.

Lord, forgive me. I haven't shown Your Spirit's patience toward the world. I have been self-centered at times. Increase my love and compassion toward others so that patience will be stirred in my heart. Show me Your heart for Your people. Quicken Your brand of love within me. Just as the world recognizes designer labels, I want to wear Your brand for all the world to see. In the precious name of Jesus, amen.

*He will make your righteous reward shine like
the dawn, your vindication like the noonday sun.
Be still before the LORD and wait patiently for him;
do not fret when people succeed in their ways,
when they carry out their wicked schemes.*
PSALM 37:6–7 NIV

No More Secrets

Father, I thank You and praise You for Your extravagant mercy. You have forgiven me when I've ignored Your Word and done what I wanted—even though I knew it was sin, the wrong thing to do. The secrets I kept were causing me stress and depression. Lord, my worry that my sins would come back to revisit me was not unfounded.

Please give me courage and peace as I go to those I have hurt and ask for mercy and forgiveness. Help me to turn away from wrong and come back into the peace of living in the light. I am a child of the light, not meant to live in the darkness. Wash me in Your forgiveness and grace as I repent. Amen.

"But if you fail to do this, you will be sinning against the LORD; and you may be sure that your sin will find you out."
NUMBERS 32:23 NIV

Check Your Anger

Lord, everywhere I look I see angry people—raging politicians, honking horns, screaming parents. I don't want to ride this roller coaster of high emotion; it looks terribly stressful and exhausting.

Grant me patience today in whatever endeavors I attempt. Help me remain calm and choose wisely how to react to the storms that roll in throughout the day—whether I have created them or someone else is responsible. When I find myself getting angry, I know that I don't always think clearly. But, Lord, if I don't practice self-control, I will end up being a fool. Help me to live out the calm and peace I experience by knowing You. May others see my restraint and give You glory. In the name of Jesus, amen.

A fool gives full vent to his anger,
but a wise person holds it in check.
PROVERBS 29:11 CSB

Dance in the Rain

Heavenly Father, when I am feeling the burden of stress, I realize that my focus is usually centered on my problems, my failures, and every little detail that doesn't go my way. Why do I miss the sea of blessings I'm drowning in?

My life's garden is watered by blessings showered down by a gracious and loving God. Lord, I am blessed! Undeniably. Immeasurably. I have breath to praise You and an eternity with You ahead of me. What are a few discomforts along the way in comparison with the richness of walking in Your truth? And even if I give my life for You, the reality is that this life will seem faint and flickering in comparison to the glorious eternity unfurling before me. Thank You, Jesus. Amen.

But joyful are those who have the God of Israel as their helper, whose hope is in the LORD their God. He made heaven and earth, the sea, and everything in them. He keeps every promise forever.
PSALM 146:5–6 NLT

Right by My Side

Father God, I'm so thankful that You invite me to cast my cares on You. No matter where I end up in life, You are there with me. Even when my strength seems to be crumbling under a load of burden, You uphold all things.

Father, I have allowed stress to get a foothold in my life, instead of surrendering it to You. My overwhelming stress has controlled my attitude, my mood, and my words and actions. Father, I repent of this habit! Please help me to identify the areas in my life that are being run by stress and give them to You. Keep my mind stayed on Your goodness and power instead. I can't wait until my eternity with You, where stress will be no more. Amen.

I know the LORD is always with me.
I will not be shaken, for he is right beside me.
PSALM 16:8 NLT

Tears of Surrender

Father, my tears have been my constant companion. Please come closer and wrap Your arms around me. I am desperate. I need You here, right now—in the midst of this mess. My thoughts are a jumbled tangle, and I'm constantly on edge. My stress keeps me awake all night as I thrash in my bed, chest tight as I'm squeezed under the pressures of life. I can hardly bear the pain that I'm feeling; it has erased my happiness. I'm not sure I can go on unless You show up here with me in my problems.

Please soothe my frayed nerves with Your peace. Grant me serenity of mind. Relax my body, soul, and mind, as I surrender to You. In the name of Jesus, amen.

Now may the Lord of peace himself give you his peace at all times and in every situation. The Lord be with you all.
2 Thessalonians 3:16 nlt

Strong Defense

Lord God, in this do-what-feels-good world, using self-control often results in frowns from friends. The world discourages me from living within Your guidelines because people don't like being confronted with their own sin. But I know that out of Your great love for us, You've given Your commands for our own benefit and happiness.

And while my life isn't stress free, even when I live Your way, my anxiety is calmed because I know that my self-control is like a protective wall around me. To live a joyful life is to follow Your laws—trying to go my own way and make up my own rules leads only to dysfunction and pain. Keep me from being overrun by sinful urges by constructing strong defensive walls of self-control. Amen.

A person without self-control is like
a city with broken-down walls.
Proverbs 25:28 NLT

Speak Life

Lord, prune my words into a tree of life. Let every word be pleasing to You. Help me remember that like an axe chopping down a tree, the words that I speak can bring down another person. Each word can bite into tender feelings just as a sharp axe cuts into the tender flesh of a tree. Even if I don't bring down the tree, I may have done permanent damage to it.

Guard me from any perverse thought today, and give me self-control over my tongue through my love for others. Teach me to speak words of kindness, love, and gentleness to anyone in my path. Help me be slow to anger, slow to speak, and quick to listen to everyone I exchange words with today. Amen.

Gentle words are a tree of life;
a deceitful tongue crushes the spirit.
PROVERBS 15:4 NLT

His Love Language

Father, people speak different love languages. Some of us feel loved when others serve us with acts of kindness, others feel loved through gifts, and yet others need physical contact to feel cared for. It's important to show our love to the people who populate our lives in the language they understand.

And the same goes for You, Father. Your Word tells me that obedience is Your love language. You say if I love You, I will listen to and obey Your Word. Help me actively show my love through my obedience. You have loved me far beyond what I deserve. Reveal areas in my life where I need to show my love through obedience to You. In the name of Jesus, amen.

"If you love me, obey my commandments."
JOHN 14:15 NLT

Live Love

"Live love." Lord, how beautifully simple and yet excruciatingly difficult this statement is. Thank You for Jesus—who illuminates the dark and twisted paths and guides me along hard roads. You grant me strength and wisdom to follow Your lead and mercy and grace when I slip up. Like a child walks in her parent's footsteps, help me keep my eyes on You and follow Your unerring example. You lived love, humility, and gentleness.

Just as Paul was Your devoted disciple, I want to stick with You no matter what. Open my eyes to the opportunities You give me to live love and follow Your example. No matter how small the decision I'm facing, help me always remember to ask, *Jesus, what would You do?* Amen.

Follow my example, as I
follow the example of Christ.
1 CORINTHIANS 11:1 NIV

Shameless

Father, what is it about shame that causes so much stress? Am I working so hard to keep my shame a secret from others? Do I think that my maneuvering and cover-ups will keep You from finding out the condition of my life? Is it the guilt I feel over failing. . .again?

My faith feels fragile at times when I wrestle with sin. And I don't like anyone to know when I've lost the battle. But, Jesus, I *believe* in You. I believe You are the Son of God who lived a sinless life for me, who died and on the third day picked Your life up and walked out of the tomb. I believe You love me, fully and unhindered. I believe You took my shame! I'm shameless and free! Amen.

As Scripture says, "Anyone who believes
in him will never be put to shame."
ROMANS 10:11 NIV

Flawless

God, teach me to love Your laws! You handed down the commandments not to control us, but to protect us from ourselves out of deep love. You had our best interests at heart. Without Your laws, how would we even recognize sin for the deadly threat that it is? And likewise, without Your laws, how would we understand Your amazing grace poured out on us?

Father, imbue me with Your strength and wisdom to avoid the enemy's traps. I've tried to keep Your laws on my own, but the effort is always futile. Thank You for sending us Jesus! I can't contain my relief that He walked out my righteousness for me so that I could thrive under grace. He was flawless. Righteous. And because of Him, You see me as flawless too! Amen.

*The LORD said to Moses, "Come up to me
on the mountain and stay here, and I will
give you the tablets of stone with the law and
commandments I have written for their instruction."*
EXODUS 24:12 NIV

Confession Is Good for the Soul

Heavenly Father, keep me from judging others because they sin differently than I do. Help me remember that sin is sin no matter what package I wrap it in. I humble myself at Your feet and confess my sins to You now. I may be able to hide my wrongdoing from people, but I can't hide it from You. You know my thoughts, and You perceive my heart. I can't lie to You, Father.

I am grieved by my behavior as I know I have grieved Your Holy Spirit who dwells in me. Forgive me. I can't do this without You. I'm in awe of Your faithfulness to forgive. I know that I don't deserve it; but, Jesus, You lavish me with grace and mercy anyway. In Jesus' precious name, amen.

If we confess our sins, he is faithful and righteous to forgive us our sins and to cleanse us from all unrighteousness.
1 JOHN 1:9 CSB

Holding It Together

Lord Jesus, You are superior to all! The radiance of God's blinding glory! You sustain all things by the mere power of Your commanding voice! No sin or looming problem is too big for You to handle. Knowing that You reign supreme over the angels and sit at God's right hand brings comfort to my soul.

I don't have to strive for perfection to earn Your love. How amazing to know that You are always there to wrap Your arms around me and tell me how much You love me, even when I fail. Forgive me when I try to control things and wear Your crown of power on my own feeble head. I can truly lay my stress to rest in the knowledge that You reign supreme in heaven and on earth. Amen.

The Son is the radiance of God's glory and the exact representation of his being, sustaining all things by his powerful word. After he had provided purification for sins, he sat down at the right hand of the Majesty in heaven.
HEBREWS 1:3 NIV

Look to Jesus

Lord, I often look in the wrong direction for my answers and then wonder why I've come out stressed and anxious. Corrie ten Boom said, "If you look at the world, you'll be distressed. If you look within, you'll be depressed. But if you look at Christ, you'll be at rest." God, she was so right.

When my gaze strays from You to this scary, frantic world, I start wishing for a Xanax. But there's more to this struggle than just me! The enemy whispers, "You are enough." But when I search inside of me, I realize how inadequate I am. But, Jesus, my good Friend, when I look at You, all these tangled emotions give way to peace. You are here in my mess—and I'm at rest. Amen.

The LORD replied, "My Presence will
go with you, and I will give you rest."
EXODUS 33:14 NIV

Longing for Home

Heavenly Father, don't let me get too comfortable here. I know this flawed world is not my forever home. This place is fraught with stress-inducing sin, death, and fear. Hardships and incomprehensible evil too often rule the day.

But I find peace and rest in knowing that my hope is in a better place—a place of wonder and light. I can just make out its shimmering silhouette in the distance, and I'm eagerly waiting for the time when I can join You there. Jesus, You've been preparing for us, and You've got to be eager to show me my stunning new digs. As I persevere through trials today, give me an unwavering eternal focus. Because my future is bright! Amen.

All these people were still living by faith when they died. They did not receive the things promised; they only saw them and welcomed them from a distance, admitting that they were foreigners and strangers on earth. People who say such things show that. . .they were longing for a better country—a heavenly one. Therefore God is not ashamed to be called their God, for he has prepared a city for them.
HEBREWS 11:13–14, 16 NIV

Scripture Index